LIFE IS GOLDEN

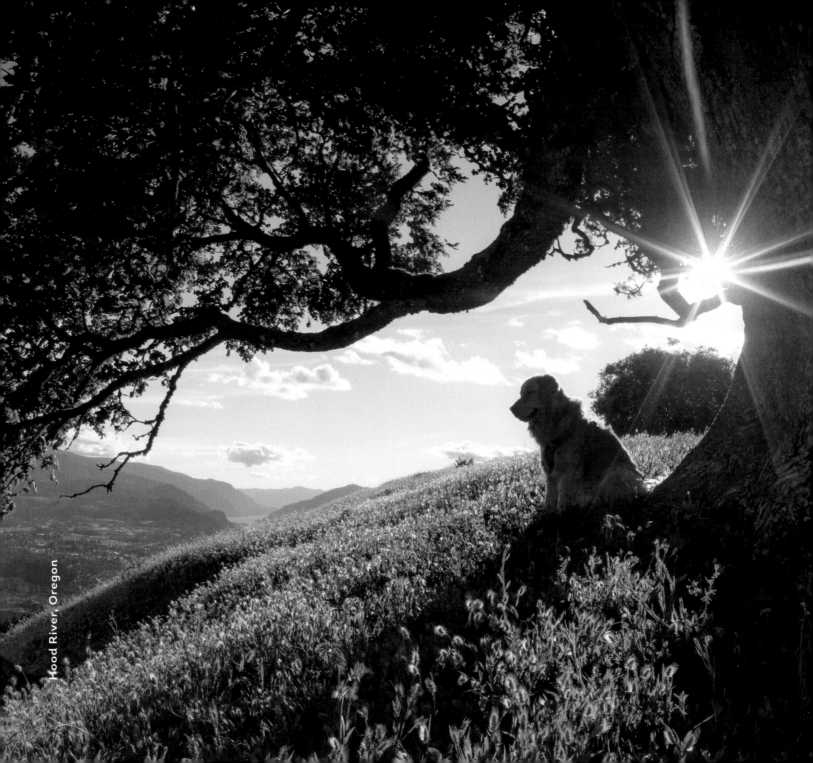

Hood River, Oregon

LIFE IS GOLDEN

WHAT I'VE LEARNED FROM THE WORLD'S MOST ADVENTUROUS DOGS

ANDREW MUSE

GIBBS SMITH
TO ENRICH AND INSPIRE HUMANKIND

First Edition

26 25 24 23 22 5 4 3 2 1

Text and Photographs © 2022 Andrew Muse

Published by Gibbs Smith
P.O. Box 667
Layton, Utah 84041

1.800.835.4993 orders
www.gibbs-smith.com

Designed by Nicole LaRue and Virginia Snow
Printed and bound in China

Gibbs Smith books are printed on either recycled, 100% post-consumer waste, FSC-certified papers or on paper produced from sustainable PEFC-certified forest/controlled wood source. Learn more at www.pefc.org.

Library of Congress Cataloging-in-Publication Data

Names: Muse, Andrew (Vlogger), author.
Title: Life is golden : what I've learned from the world's most adventurous
 dogs / Andrew Muse.
Description: First edition. | Layton, Utah : Gibbs Smith, [2020]
Identifiers: LCCN 2021025287 | ISBN 9781423660279 (hardcover) | ISBN
 9781423660286 (epub)
Subjects: LCSH: Adventure travel—Pictorial works. | Dogs—Pictorial works.
 | LCGFT: Illustrated works.
Classification: LCC G516 .M87 2020 | DDC 910.4—dc23
LC record available at https://lccn.loc.gov/2021025287

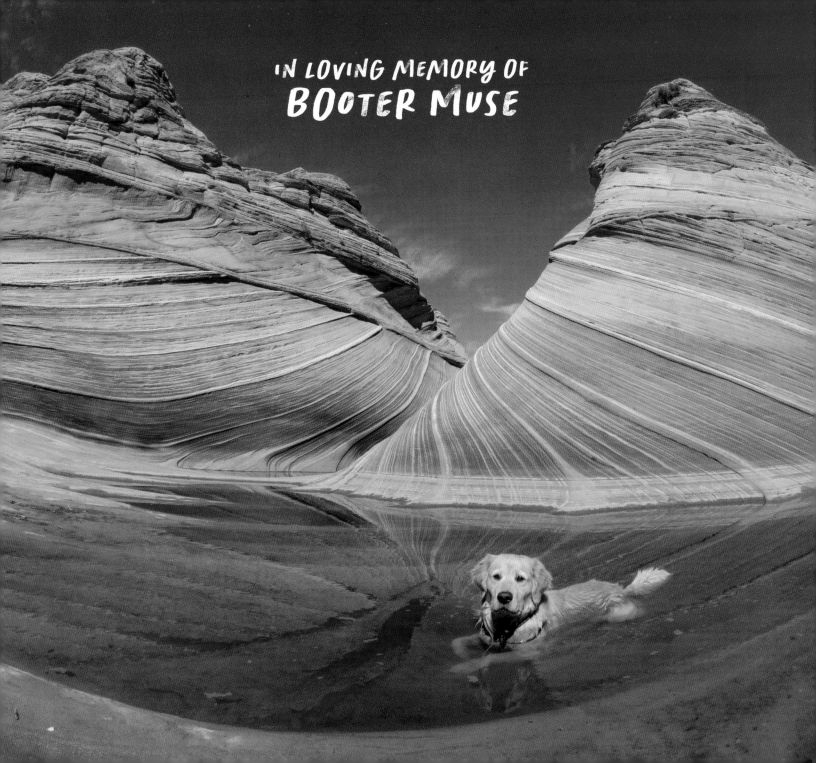

IN LOVING MEMORY OF
BOOTER MUSE

Bonneville Salt Flats, Utah

cONTeNTs

Moab, Utah.

LOVE AT FIRST SIGHT

Dogs have changed my life. The love I have received from my dogs has been pure, unconditional, and special. It's a deeper emotional connection than any I have ever had with a human. And it all began with Booter.

Because I grew up in a single-parent household where substance abuse issues strained relationships, my family moved around a lot, and life was often unstable. We had a few dogs over the years, but more often than not, against my will, the dogs we *did* have tragically ended up in the care of a shelter after just a year or two. Even at a young age, I recognized this behavior was wrong.

So when I first felt it was time for me to find a dog of my own, I forced myself to wait. I did not want my dog to suffer the same fate as all the dogs I had known before. Even after I left home and was on my own, I

knew I needed to hold off until I was in a position where I could give a dog the best life possible: I wanted my dog to be immersed in the outdoors, chasing adventures and experiences, but I also wanted to make sure I could provide a forever home.

Five years after leaving Massachusetts to pursue happiness in the mountains of Utah, I had built a life where I could give a dog the time, love, and attention I knew it deserved. I was working at a local park doing landscaping, so I was financially stable and could bring a dog to work with me. I lived in a town with outstanding access to nature and the mountains, in a house with a huge yard and a few roommates who took great care of their own dogs. A life full of adventure, love, good food, and attention was the best existence I could imagine for a dog.

I spent months researching dog breeds, going to shelters, and reading books on dog training to find the perfect fit for my active lifestyle. Eventually I landed on a golden retriever. Goldens are athletic, rugged, and loving—the list of their desirable characteristics goes on and on—and they thrive in the type of climate I lived in. Because the shelters in my area didn't have golden retrievers available for adoption and provided next to no information about the dogs they did have, I decided to meet a local breeder and look at a litter of five-week-old goldens.

When I met the puppies, one quickly stood out as a bit of an oddball, while another was shaky and nervous. And then this little furry nugget came strutting over, cool as a cucumber, and fell asleep on my then-girlfriend's lap, sucking her finger. I knew right then: this was my guy. A few weeks later, I came to pick him up, and things just clicked. The look on his face said, *Cool, you're my dad now*, and I couldn't have been more excited to become the *best* dog dad I could be!

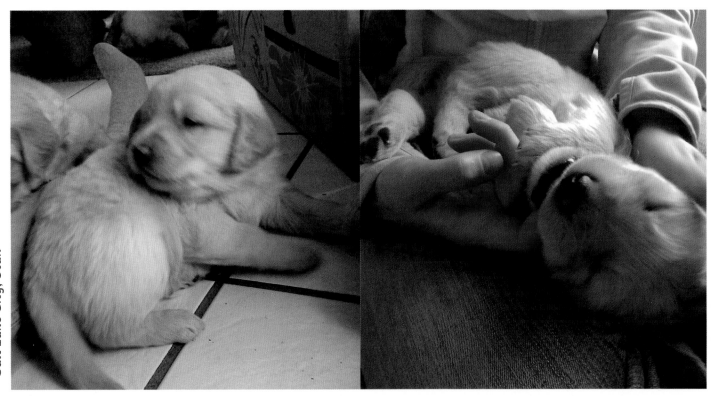

Salt Lake City, Utah

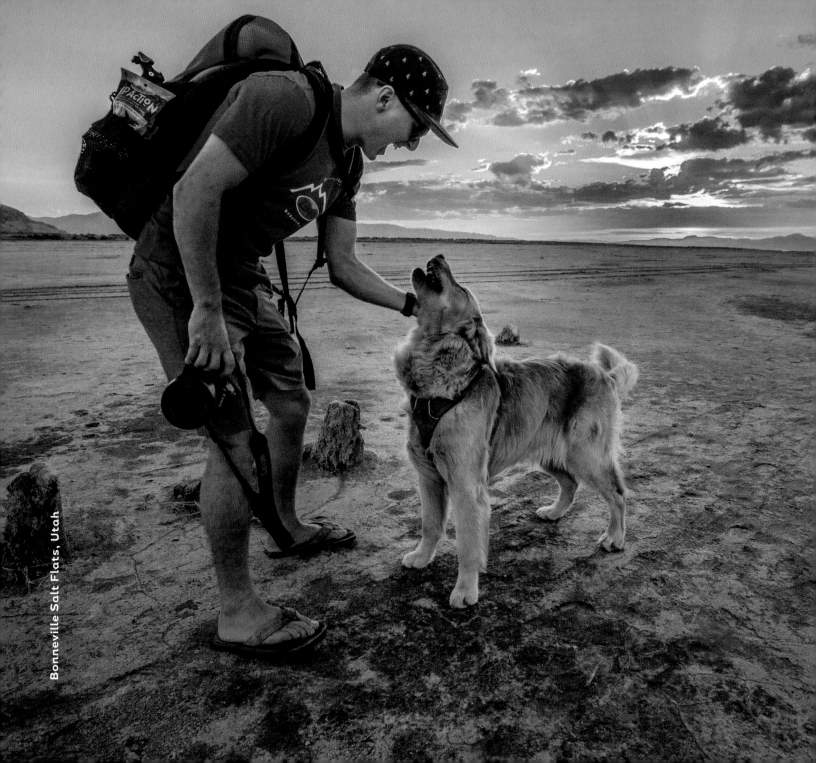

Bonneville Salt Flats, Utah

OUR FIRST ADVENTURES

At first, I had trouble thinking of a name for my new pup. Snowboarding has always been a major force in my life and I eventually decided that "Booter"—the term for an extremely big jump in snowboarding—was the perfect fit for this active puppy so prone to getting underfoot.

For the first few months, Booter and I rarely spent more than two hours apart. We took our first big adventure to some remote hot springs in Utah. I knew the trail would be far too long and steep for a puppy to hike on his own, so I brainstormed a few ideas to safely carry him. A cloth shoulder bag allowed him to lie down with his two little paws and adorable snout poking out of the opening. I wasn't sure how well he would tolerate it on the hike, but he actually seemed to enjoy it. I would let him walk alongside me for a bit before tossing him in the bag and carrying him as he slept. When we made it to the springs, he was all tuckered out and slept cozy as could be on some towels while my

friends and I enjoyed the warm water and beautiful setting. I couldn't help but just stare at my sweet, innocent dog. He was an absolute angel. I took a moment to appreciate that this was the beginning of the life I had dreamed of as a child.

After the hot springs, I took Booter rock climbing, and he again handled everything thrown his way. He would hike for a couple of minutes before I tossed him back in the bag where he slept, nuzzled deep into a pair of my shoes, warm, happy, and peaceful. (I think this is where his passion for dirty socks started.)

From that point forward I decided to take him on all my adventures, and it became my top priority to keep Booter warm, happy, and safe. Because he was so little at first, it was also important to protect him from overexerting himself, as puppies so often do without realizing it. This is essential to raising a dog keen for all kinds of adventure. You want to introduce puppies to new things often and early, but always in a way that's lighthearted and fun. Anytime I'm on an adventure with a dog, I make sure to operate well within my own comfort zone so I can keep both of us out of trouble.

Booter and I did everything together, from backcountry skiing to rock climbing in the Uinta Mountains to paragliding at Point of the Mountain,

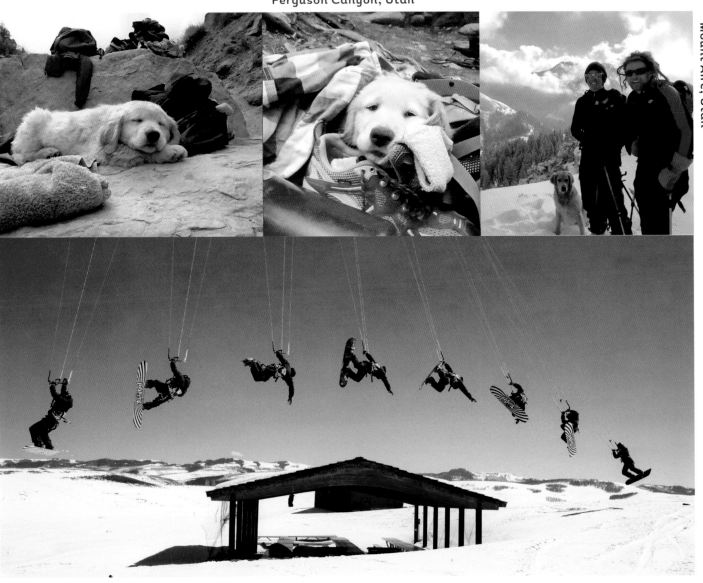

Fifth Water Hot Springs, Utah

Ferguson Canyon, Utah

Mount Aire, Utah

Strawberry Reservoir, Utah

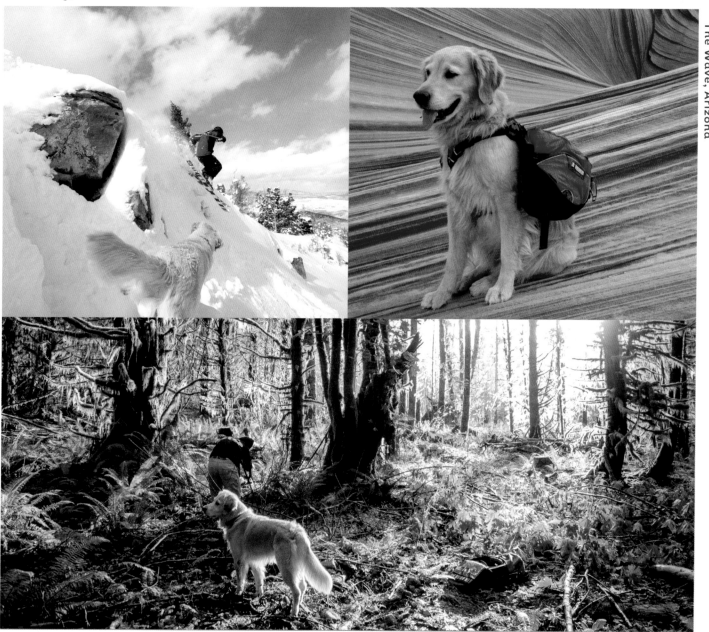

The Wave, Arizona

Olympic National Forest, Washington

all in Utah. For three months, we even lived out of a Chevrolet Astro van known as "El Toro." We spent as much time as possible in the mountains or desert, building the strongest bond I've ever felt with any animal or human. The unconditional love Booter gave me, and the way I loved him back, made him far more than just a "pet"—he was now family and an extension of my own being. All we had to do was look at each other, and he would know what I wanted from him, and I would know what he needed from me.

Booter's personality flourished. There was something so special about him and the way he interacted with people and the world around him. Even friends who had dogs of their own would talk about his exceptional temperament. He was polite and kind. He would often, very methodically, go from person to person around a campfire to sit by their side, rest his head on their knee, and absorb their love for just the right amount of time before moving on to the next person. And he did this in a way that was nonintrusive and totally welcomed. I had never seen anything or anyone so capable of absorbing and giving love like Booter. I quickly realized that he was even better than the ideal dog I had imagined.

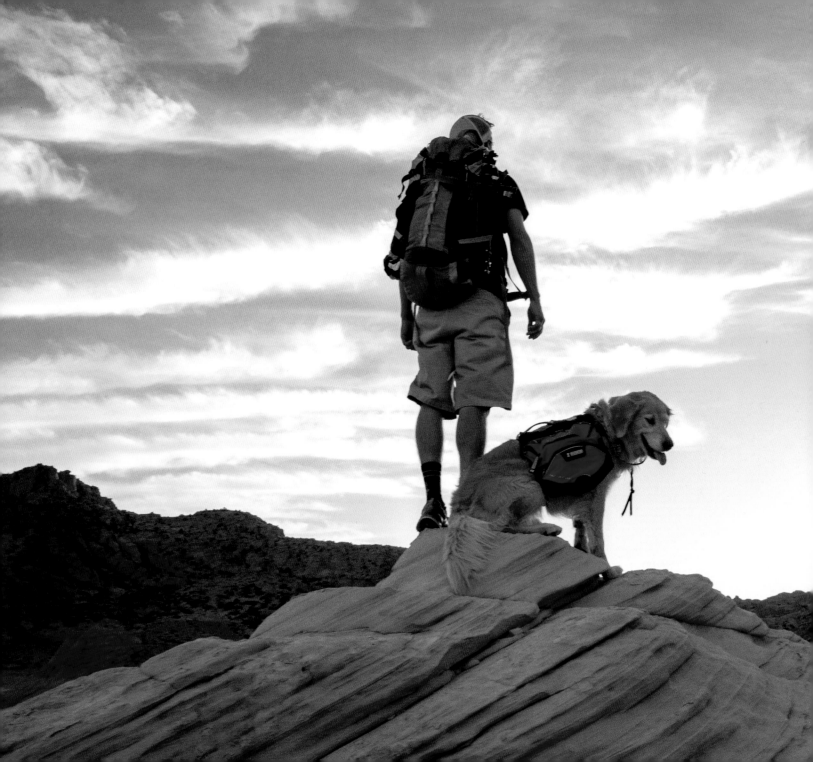

ENJOYING THE LAST MOMENTS OF SUNLIGHT BEFORE GETTING READY TO SHOOT THE MILKY WAY AT THE WAVE, ONE OF THE MOST STUNNING ROCK FORMATIONS IN THE COUNTRY. I CAN'T COUNT HOW MANY SUNSETS BOOTER AND I WATCHED TOGETHER, BUT EACH OF THEM FILLED MY HEART WITH SO MUCH LOVE AND GRATITUDE.

The Wave, Arizona

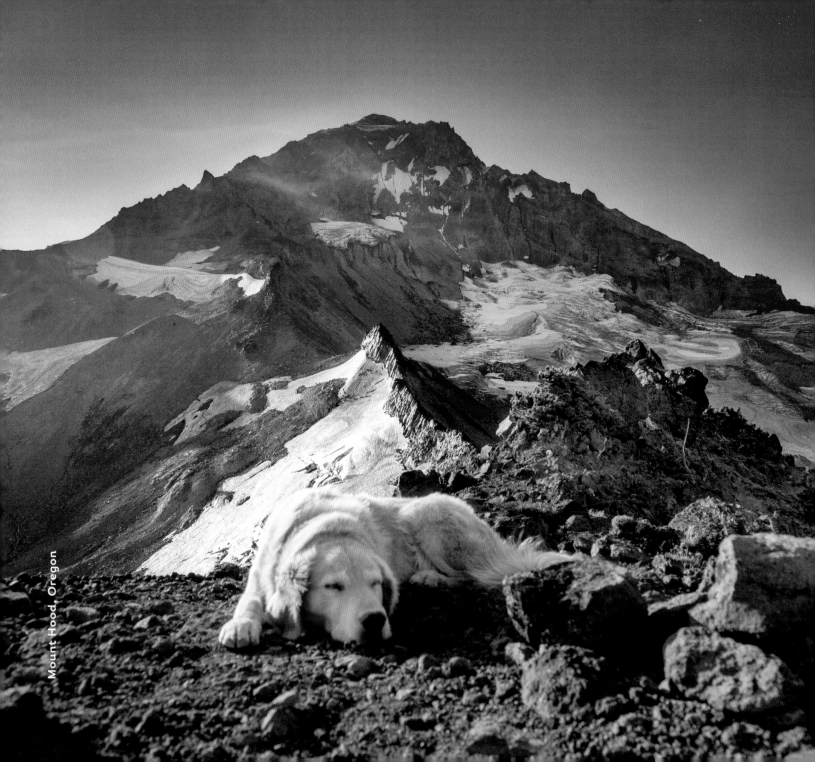

Mount Hood, Oregon

AT HOME ON THE ROAD

Over the next five years, as my bond with Booter grew stronger, so did my abilities as a multisport athlete and filmmaker/photographer. I was beginning to make a little money and follow some bread crumbs on the path to making a career out of these adventures. I was ready to commit full-time to making my passions a career. So I bought a 1976 truck camper for $500, and moved from the bedroom I was renting to the garage so I could save money while I worked on turning my dark and dingy camper into my home for the foreseeable future.

Buying this truck camper awakened something within me. I had always been a hard worker, but this brought to life a whole new inner drive. I would work until the late hours of the night and get up again at sunrise, feeling motivated and excited to continue building this dream. I knew that if I wanted to get paid to live the life I was imagining, I was going to need to generate value for other people and companies. I decided

to produce an action/sports/travel series called *Tiny Home Adventure*, starring myself and Booter. I reached out to a couple hundred different brands and got modest support from four of them. I decided to go ahead with my plan, hoping that perhaps a network would pick it up after I filmed the pilot.

I eventually quit my job and committed to spending six months on the road. During this time, Booter and I had nonstop incredible adventures. We saw some of the most beautiful places Utah has to offer, from the Wave, a sandstone rock formation just outside of Kanab, to the canyons of Moab, where I swung on a giant rope swing with Booter in a climbing-grade harness.

After we finished filming the twelfth and final episode of *Tiny Home Adventure*'s first season, I traveled to Santa Barbara, California, to watch my sister get married. I remember thinking to myself that this was the first time in my life where things were going well for my mom, my sister, and me. I was happy. Unfortunately, this perfect moment didn't last long.

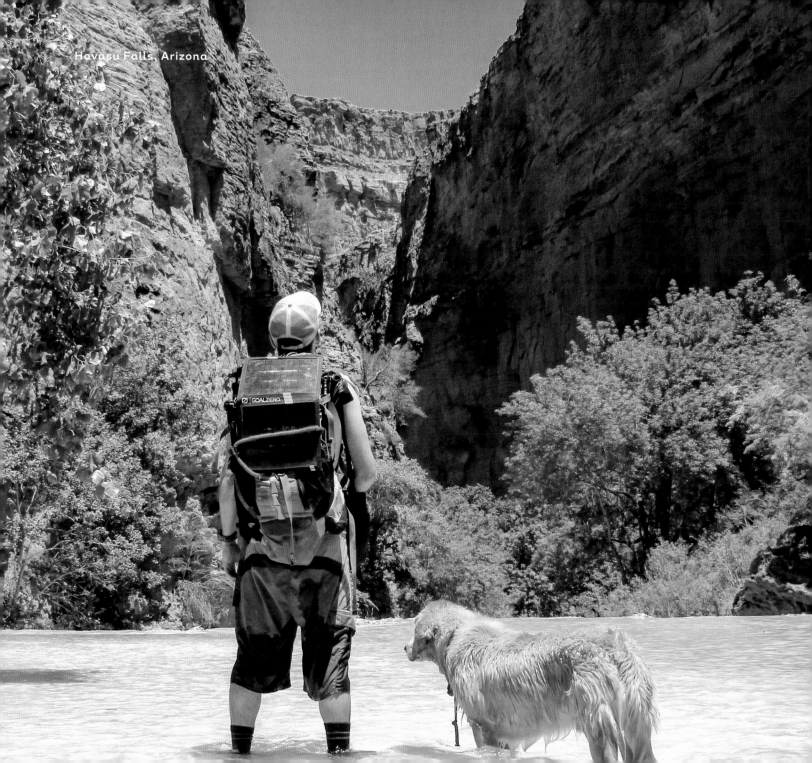

Havasu Falls, Arizona

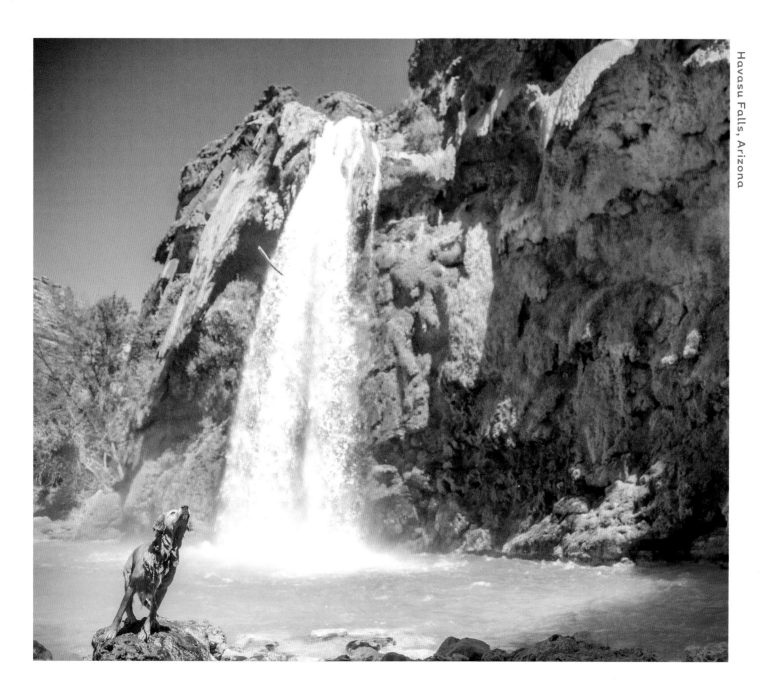

HAVING THE PRIVILEGE TO EXPLORE SOME OF THE MOST BEAUTIFUL PLACES ON EARTH IS ENHANCED ONLY BY BEING ABLE TO SHARE IT WITH MY DOG.

The Wave, Arizona

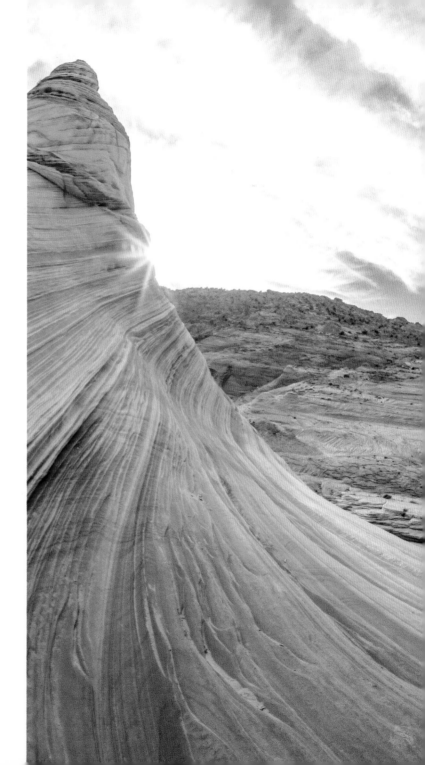

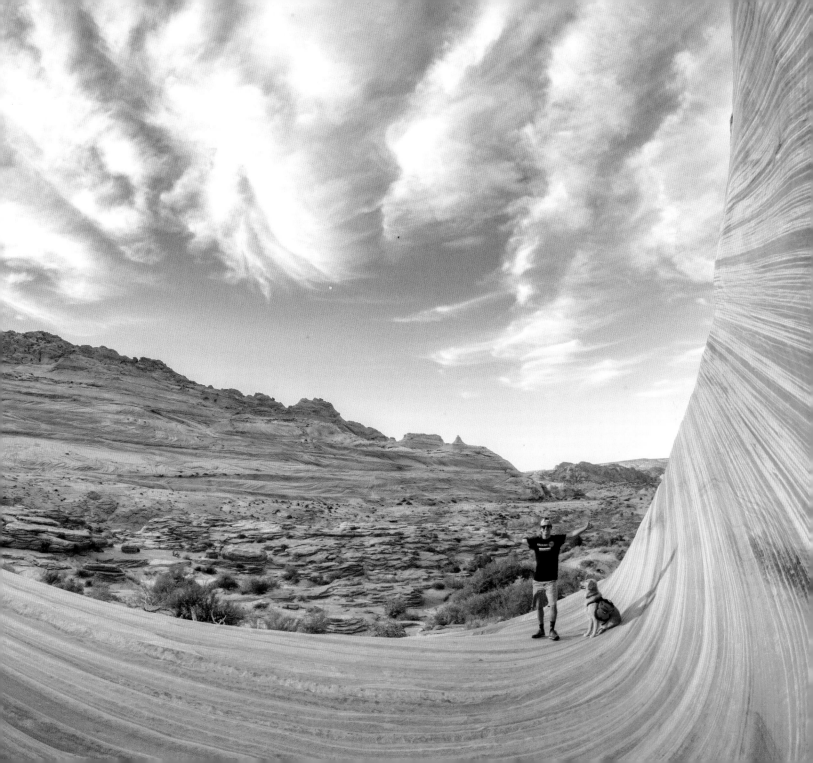

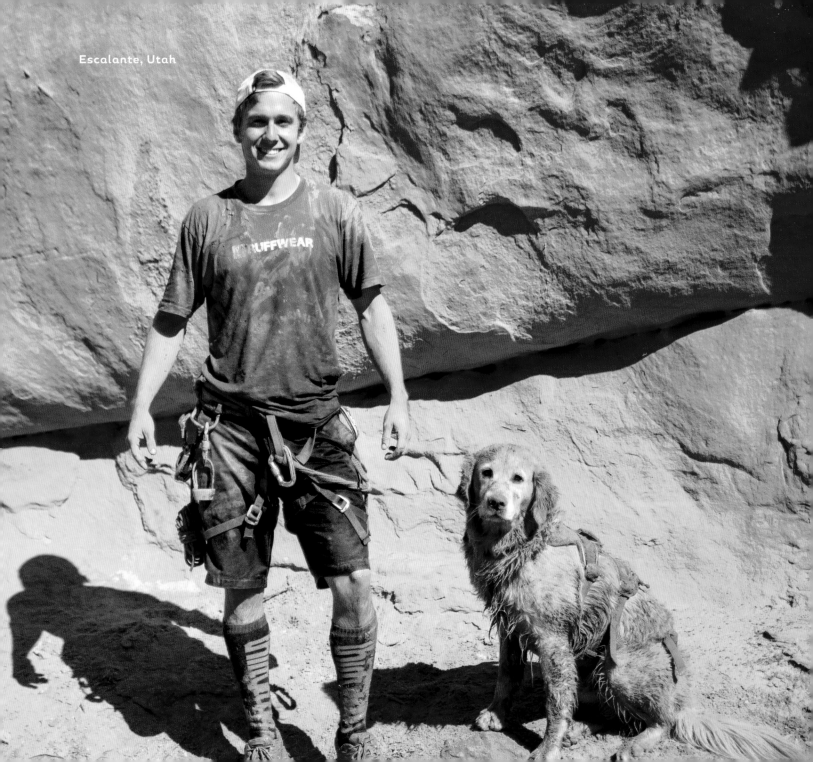

Escalante, Utah

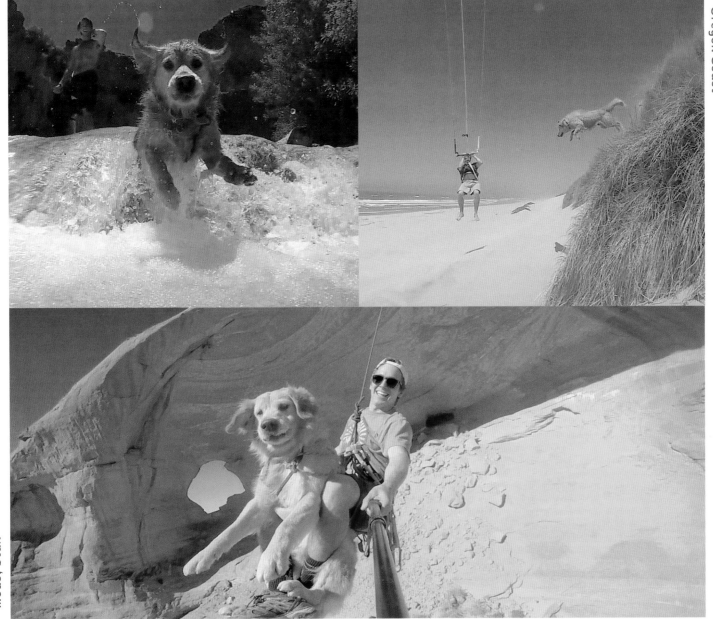

Oregon Coast

Moab, Utah

AFTER A LONG DAY OF HIKING
AND CLIMBING IN YOSEMITE
WE RELAXED BY THE FIRE TO
PREPARE FOR THE NEXT DAY'S
ADVENTURES.

Yosemite, California

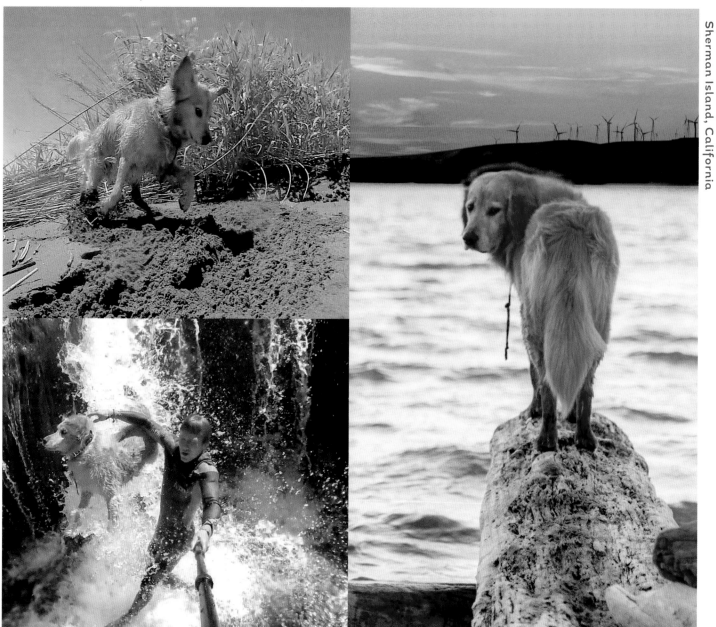

Sherman Island, California

Sherman Island, California

Umpqua National Forest, Oregon

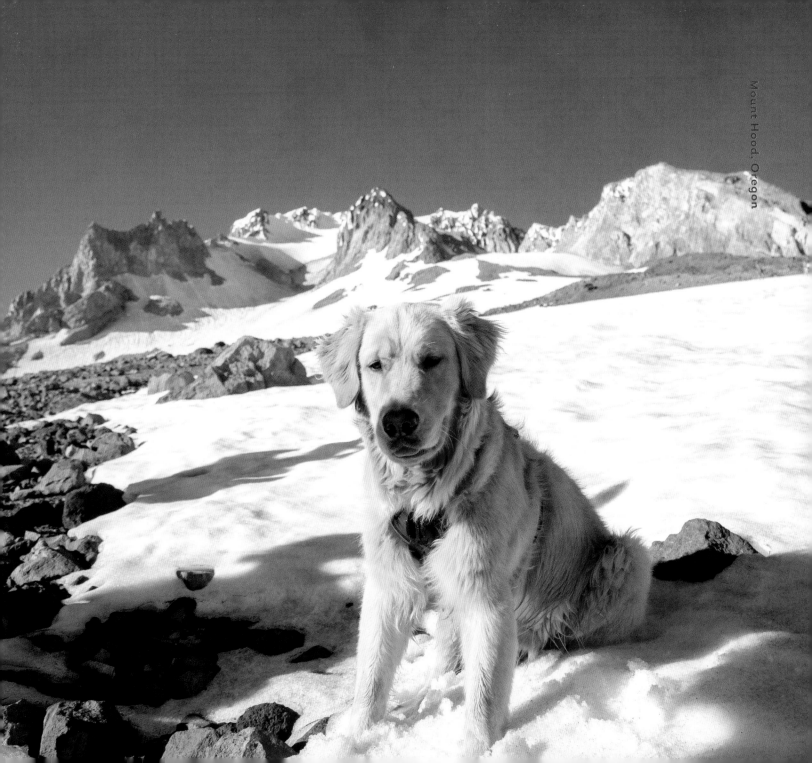

Mount Hood, Oregon

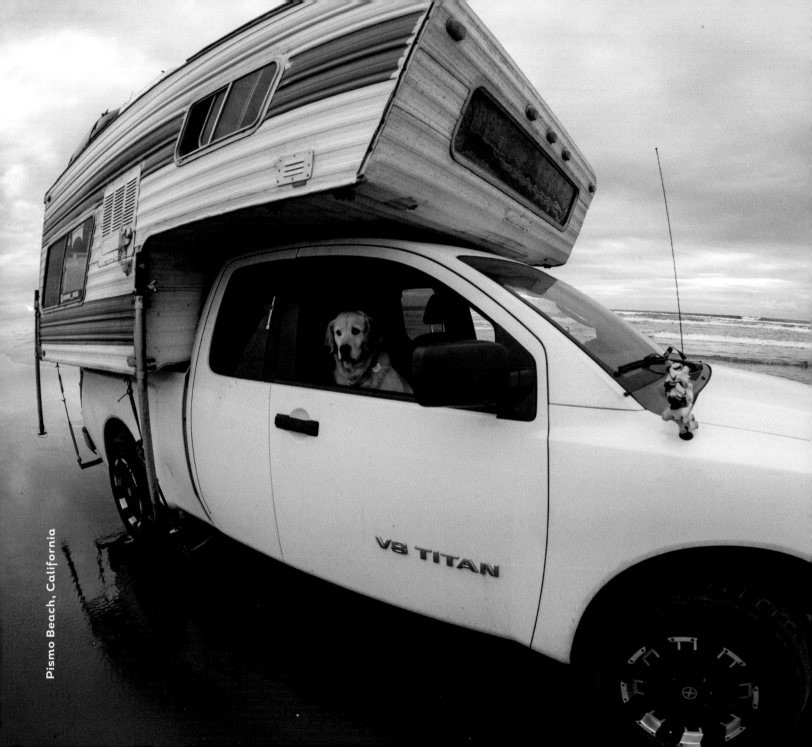

Pismo Beach, California

THE ACCIDENT

After my sister's wedding, I wanted to get back to my home base in Park City, Utah, as quickly as possible to finish editing the final episode of *Tiny Home Adventure*. I was on a strict, self-imposed biweekly deadline, which I had hit for the previous eleven episodes, and I wanted the final episode to be edited to the best of my ability to serve as the proof of concept for a more financially sustainable Season Two.

I left early in the morning from Santa Barbara with the intention of getting back to Park City that night. But the driving was slow, and I started to get tired. I realized I wasn't going to make it. I said to myself, *If I can drive another hour, I'll be within two hours of Park City and can spend a full day editing tomorrow.*

This was the biggest mistake of my life. I fell asleep behind the wheel and rear-ended an 18-wheeler. It was going thirty miles an hour, and I was going sixty. When I came to, the back end of the 18-wheeler—which was still moving—was inside the cab of my truck, only sixteen inches from my right shoulder. I knew Booter was in the passenger seat next to me. With every part of my being, I screamed a bloodcurdling "NO!"

My legs were trapped, but thankfully people had pulled over to help. Everyone was shocked I was alive. As soon as my door was open, I freed my legs and ripped out the center console to get to Booter. He was unconscious but still breathing. I asked the bystanders to call an emergency vet for Booter, and when the paramedics arrived, I refused care and demanded they try to save him instead of me. But there was nothing anyone could do. He passed away in my lap on the side of the road.

In those few short moments, I lost it all—my home, my truck, and all of my belongings. But the worst part was that I had lost my best friend, my soul mate, and the most important thing in the world to me. Booter was gone. I would have given everything to save him. I felt I had nothing left to live for and thought I never would. I wanted to be dead.

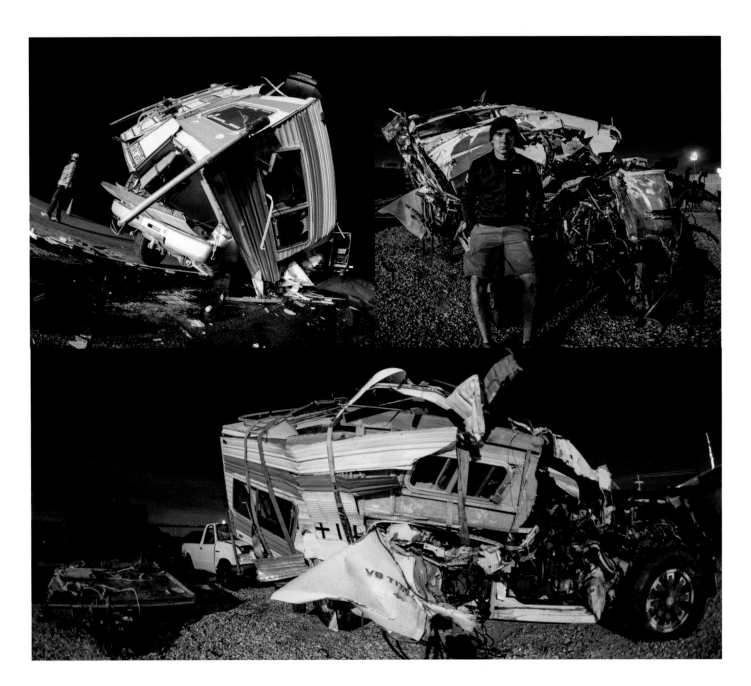

Eventually, a firefighter put his arm around my shoulders, and gently said that he was so sorry. He told me that he had lost dogs before and understood my pain. His name was Paul, and he helped me through one of the hardest nights I'd ever had. Little did I know that he would become one of the most important people in my life.

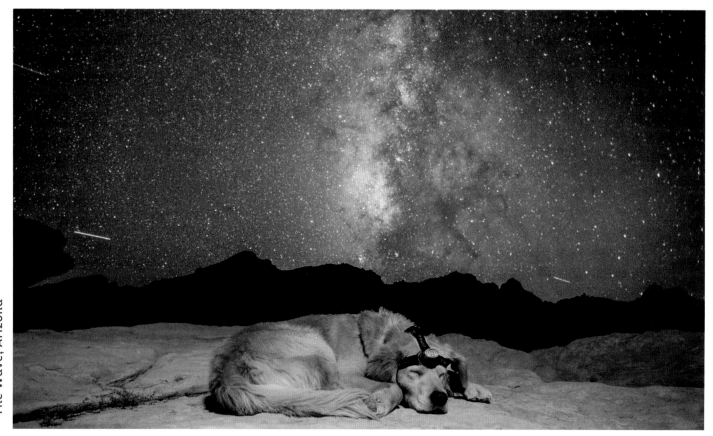

The Wave, Arizona

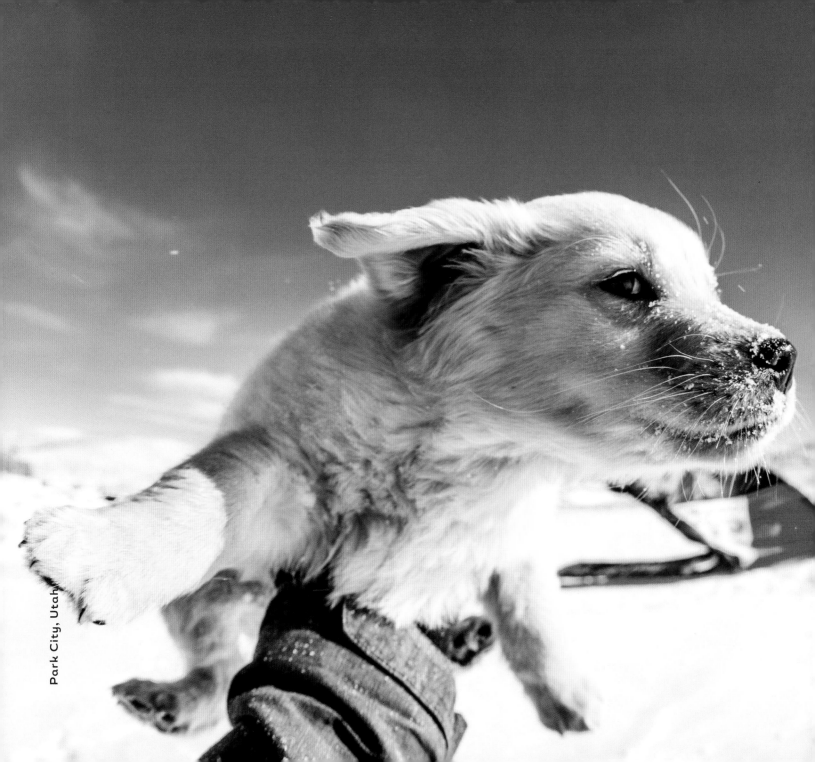

Park City, Utah

NEW BEGINNINGS

In the aftermath of the accident, I had shared my number with Paul and, a few months later, he called to say that he and his family bred golden retrievers. When I was ready, they had one for me. At that moment, my life was so uncertain I wasn't sure I would be able to give a dog the quality of life that was, for me, a nonnegotiable part of dog ownership. But a few more weeks went by, and to my disbelief, my shattered life started to piece itself back together. Up until that point, I had never had a safety net in my life, and I had never learned how to lean on other people for help. But now that I was at rock bottom, my community rallied around me.

Before I knew it, I had a place to stay, a car to drive, and clothes on my back, all thanks to the incredible people of Park City, Utah. The brands I was working with continued to support and elevate our partnerships—in fact, GoPro, a brand I had been wanting to collaborate with for

many years, expressed serious interest in collaborating on a potential Season Two of *Tiny Home Adventure*. On top of all that, I had people from around the world reaching out to tell me how the connection I had with Booter and the adventures we shared had inspired them. People wanted me to keep going. I had thought the content I was creating was just a fun documentation of my life, but apparently following my passions and dreams had inspired others. This support and encouragement lit a fire in me to rebuild through the pain and depression.

Even now, I honestly question whether having a pet is worth the inevitable pain of losing it one day. I still hurt deeply from what happened to Booter. And I had other concerns as well: How could another dog live up to Booter? What if this new puppy wasn't a good match? What if it hated the water? Or the snow? Or camping? Despite my apprehension, however, I decided to take Paul up on his offer. I was terrified, but I went to meet the puppies when they were five weeks old, the same age Booter was when I met him.

I ended up spending over four hours with Paul's family, trying to pick from three adorable pups. When I met Booter, he stood out from his littermates immediately. But these three pups were all very similar. They all seemed strong and adventurous with great personalities, but I felt the strongest connection with an active, playful, loving pup I decided to call Kicker—the name for a smaller snowboard jump.

Paul Arnold, Paragonah, Utah

Cedar City, Utah

Cedar City, Utah

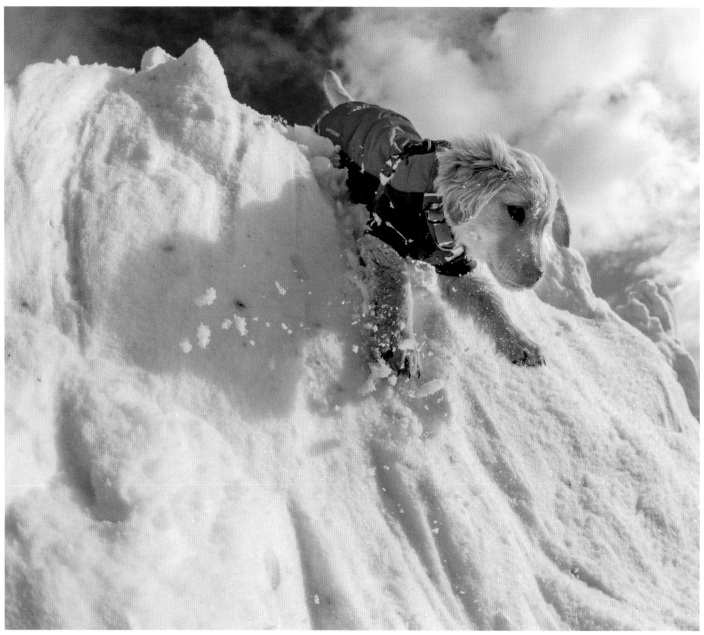

For the next few weeks, I buried myself in work, getting ready to receive what I knew would, again, become the most important thing in my life. Paul's family would occasionally send photos of the pups, and it was fun to see Kicker already breaking away from the pack on his own expeditions.

And then the day came to pick him up. When I showed up at Paul's place, I felt so many emotions at once: joy, anxiety, sadness, but mostly excitement. I was hopeful that this was going to be another incredible bond. Kicker was a chunky little ball of fur with an intrepid personality, exactly the kind of pup I was looking for. After spending a few hours enjoying the company of Paul's family—and eating their fantastic Thanksgiving leftovers for dinner—Kicker and I headed out for Park City.

When we arrived, there was about five inches of snow on the ground. I anxiously plopped him down and waited to see how he would react. He didn't skip a beat: He had full-on puppy zoomies through the snow. He dashed around the yard—slipping, falling, burrowing his face into the snow, chasing me. In that moment, a huge weight lifted from my shoulders. Though I realized even then that I would always miss Booter, I was overjoyed to have a new companion. I knew that if I gave Kicker time and grace to come into his own, we would have a very special connection.

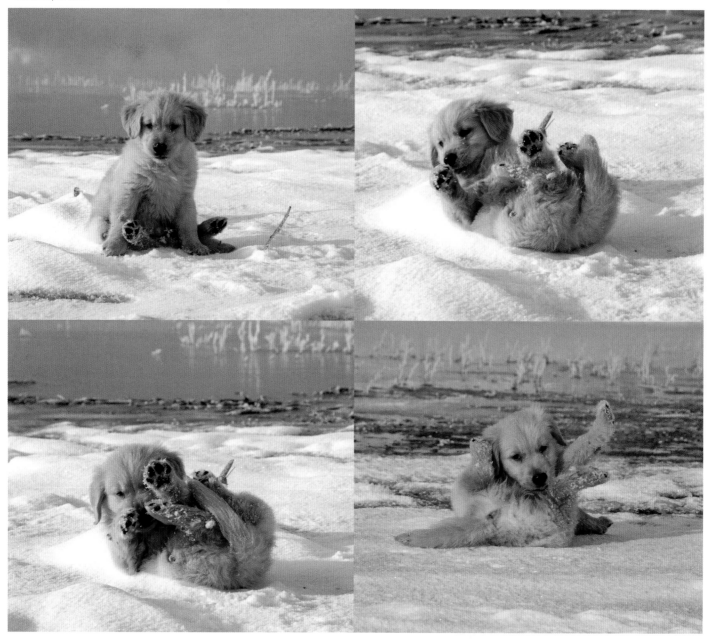

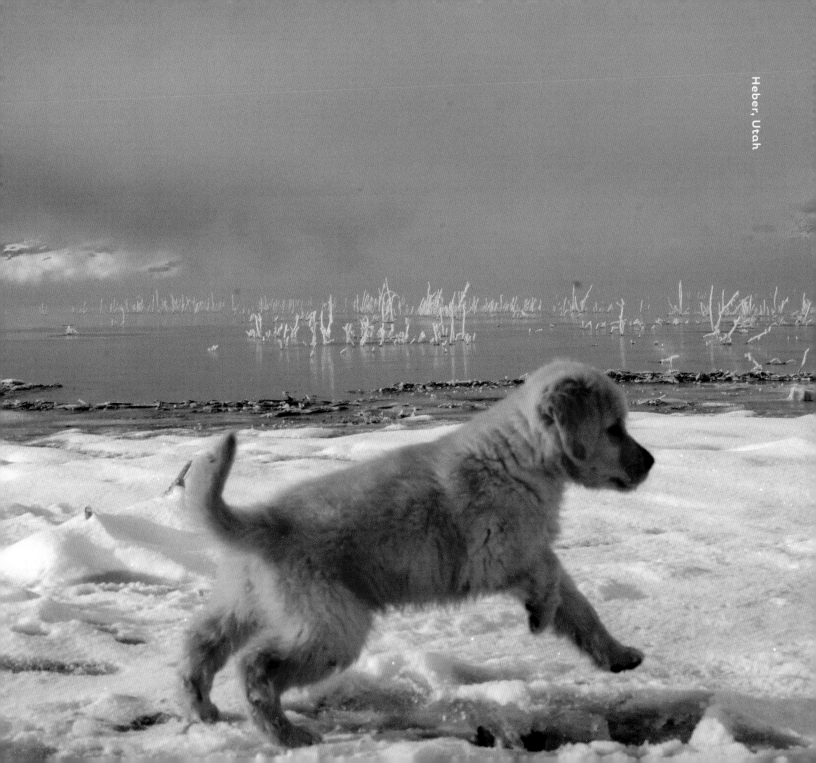
Heber, Utah

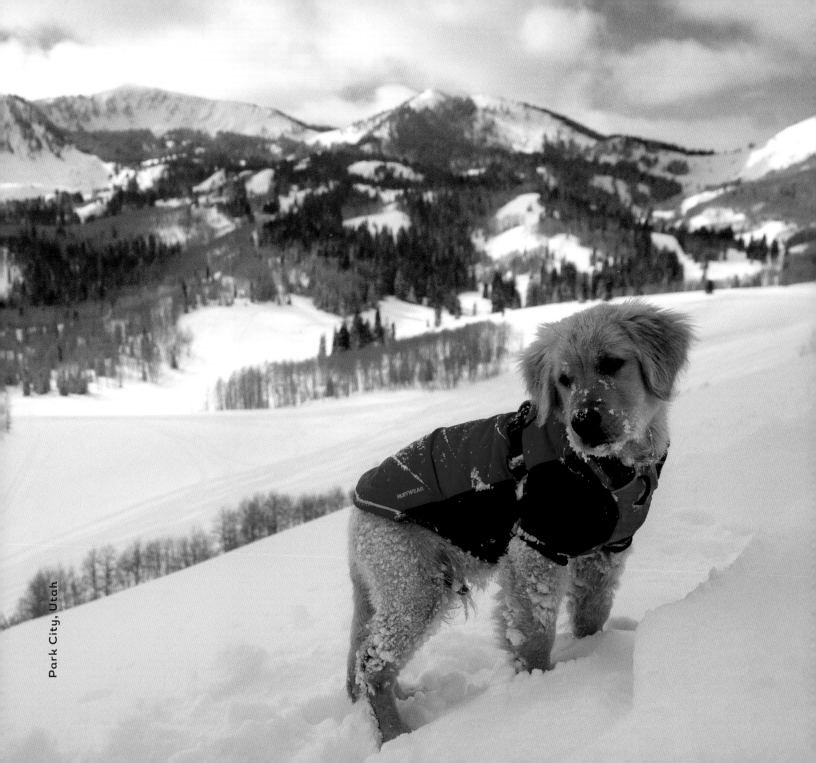

Park City, Utah

LIFE WITH KICKER

By the time I took Kicker home, I was living in a van I had just finished building, so he was thrown into van life from day one. At this point I knew how to raise an outgoing, adaptable dog, and my life was far more adventurous than it had been when Booter came into it. We hit the ground running.

Right out of the gate, I took him ski touring, which is a lot like cross-country skiing but in wilder terrain. You use climbing skins to go up the mountain, and then you ski back down through untouched snow. At first, Kicker would just stay nestled in my jacket, but as he got stronger, he would run on his own for a little while before I carried him again. We also went on some winter camping adventures in the high peaks of the Uinta Mountains, and we tried snow kiting (similar to kiteboarding except the kite pulls you on a snowboard over snow instead of on a wakeboard over water).

Kicker's affinity for the mountains was obvious. He ran around while I skied. He learned to speed-fly and kiteboard. With each new day, he got stronger and more self-sufficient. The similarities between him and Booter were apparent, though I did start to notice two main differences: Kicker was generally more affectionate than Booter had been, and he was significantly smellier! One time he vomited all over the new cushions on my bed. Boy, did that stink for days! Still, living in a van with a new puppy was great.

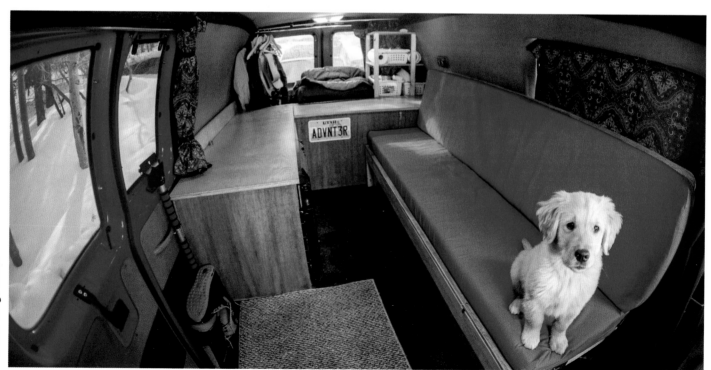

Park City, Utah

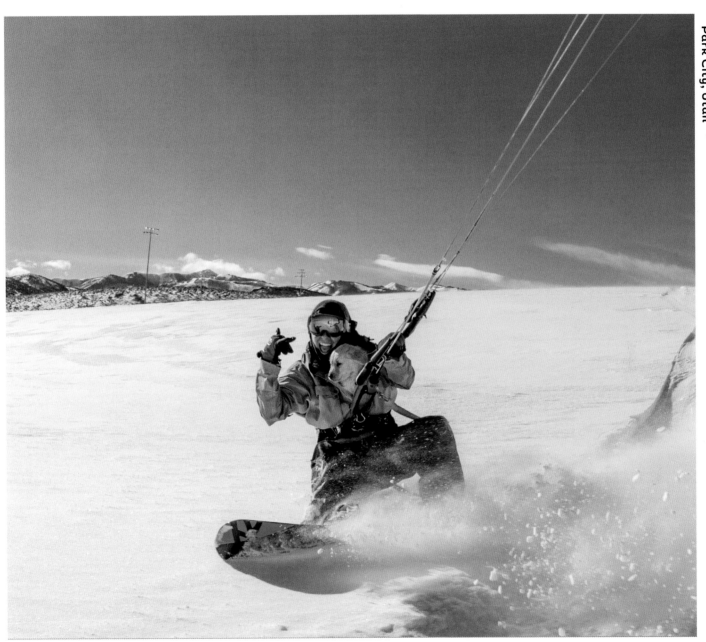

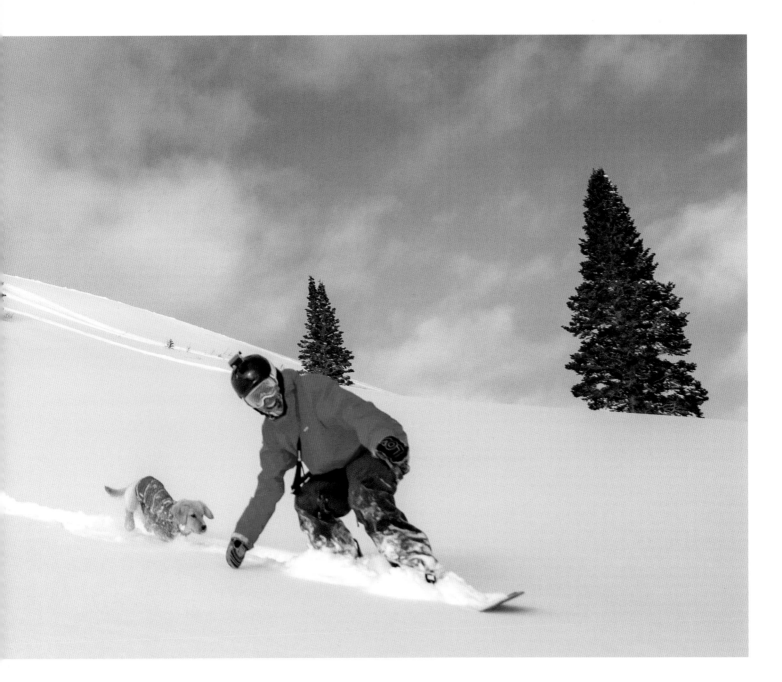

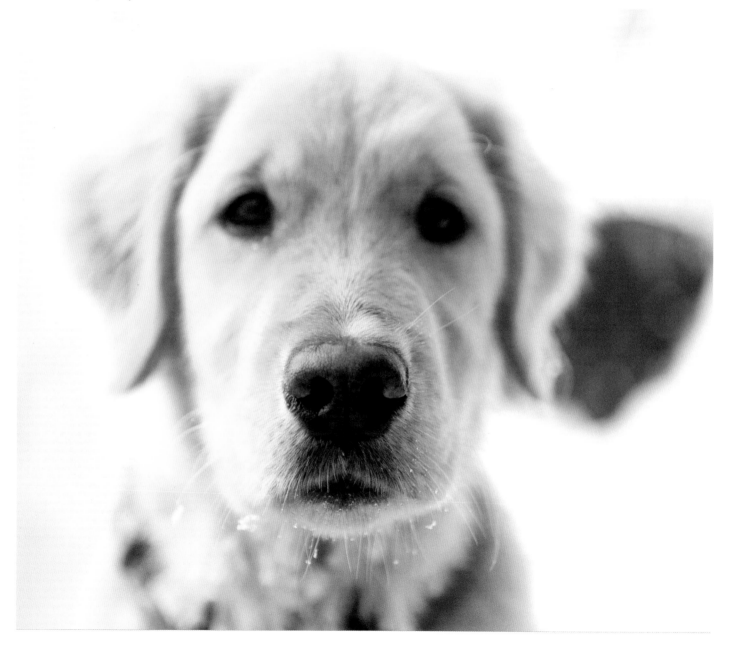

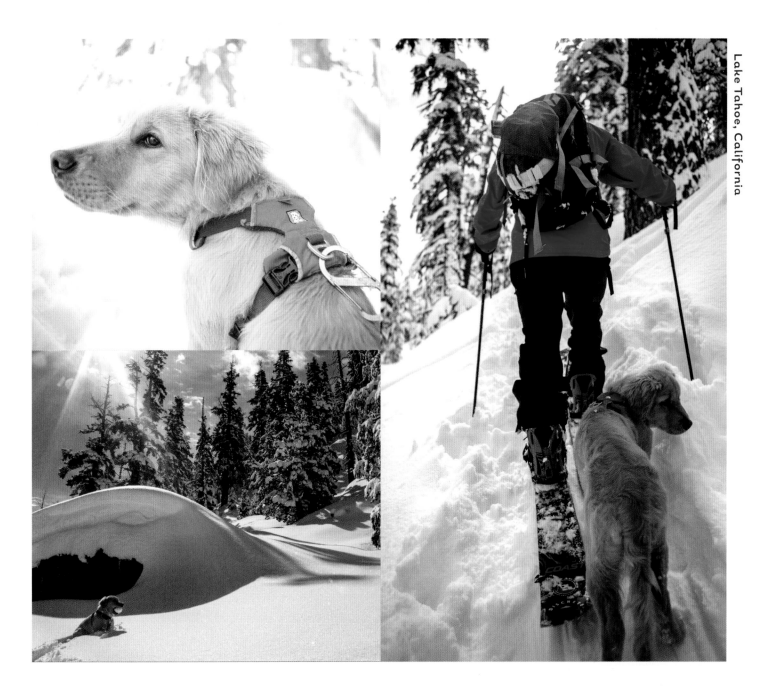

DURING ONE OF OUR FIRST TRIPS, WE CHASED A STORM TO THE TAHOE AREA. THIS WAS KICKER'S FIRST FULL DAY IN THE MOUNTAINS SKI TOURING. HE GOT A LOT OF SHOULDER AND BACKPACK RIDES BUT ALSO GOT TO RUN AND ROLL AROUND IN THE DEEP SNOW. WE CAUGHT A LITTLE AIR, TOO.

Lake Tahoe, California

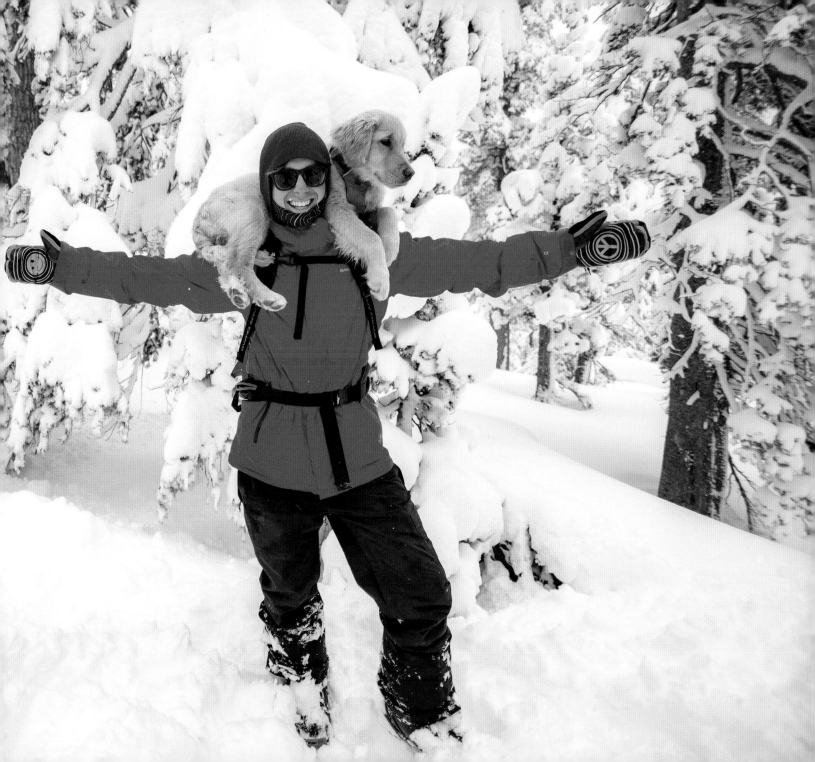

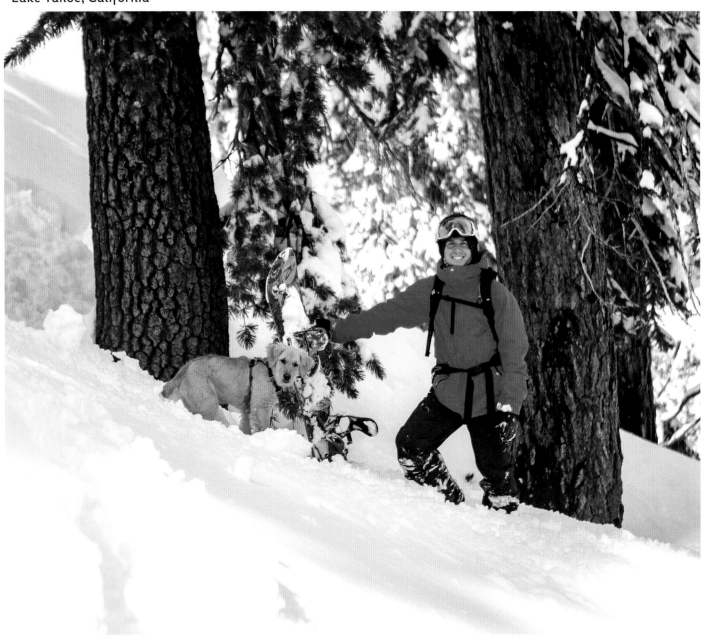

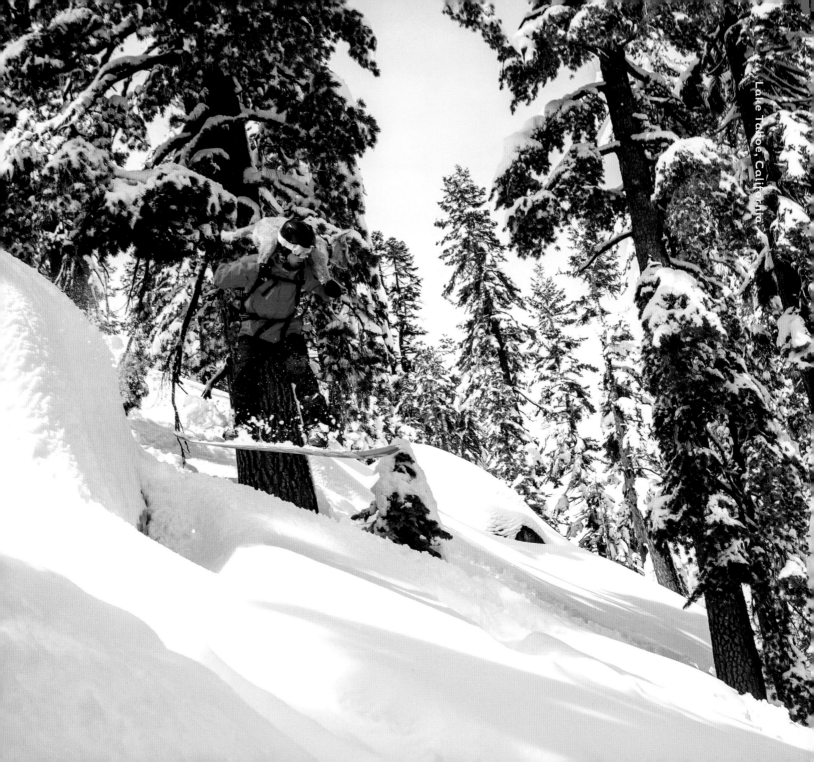

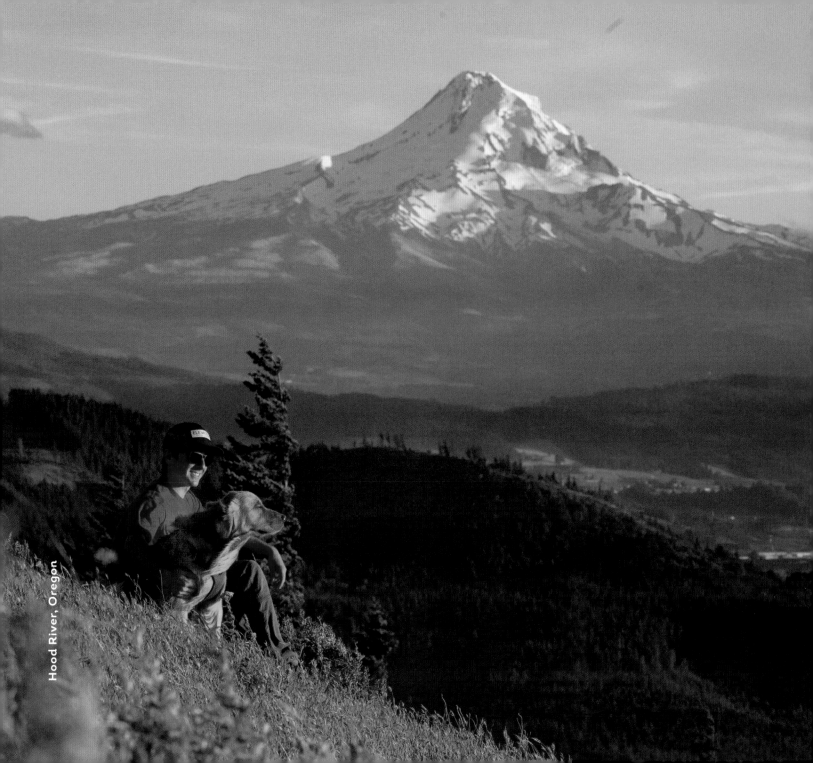

Hood River, Oregon

INTO THE LAST FRONTIER

After a few weeks of getting to know each other, Kicker and I headed to Alaska and started filming Season Two of *Tiny Home Adventure*. Right from the start, Kicker was a great companion for photo shoots, which are one of the things I truly love doing. It can be very challenging to photograph animals, but I've learned that if you make something fun and enjoyable, the photos usually turn out the best. Booter and I had photo shoots down to a science, but learning how to work with Kicker was tricky at first. Although our first shoot was a little awkward, he eventually came into his own. Full of personality and curiosity, his joy was apparent on camera.

I had dreamed of visiting Alaska since I was a child, so being able to share this trip with Kicker felt incredible. There's something to be said for shared experiences and how they help develop a strong bond. Together we kayaked, snowmobiled, and even ended up exploring deep blue ice

caves in Worthington Glacier. Kicker learned to come snowboarding with me in the mountains of Alaska. He would hike part of the way, and I would carry him the rest. I would always let him run next to me as I boarded, but I usually ended up tossing him on my shoulders for the rest of the ride down—he had grown far too big to fit in my jacket.

Alaska wasn't the only adventure Kicker and I took during the filming of Season Two of *Tiny Home Adventures*. We visited Colorado, Oregon, Washington, Idaho, and even Canada. He was constantly put into new and exciting situations and would rise to each occasion with confidence and grace. My job was to keep him happy and safe along the way.

Haines, Alaska

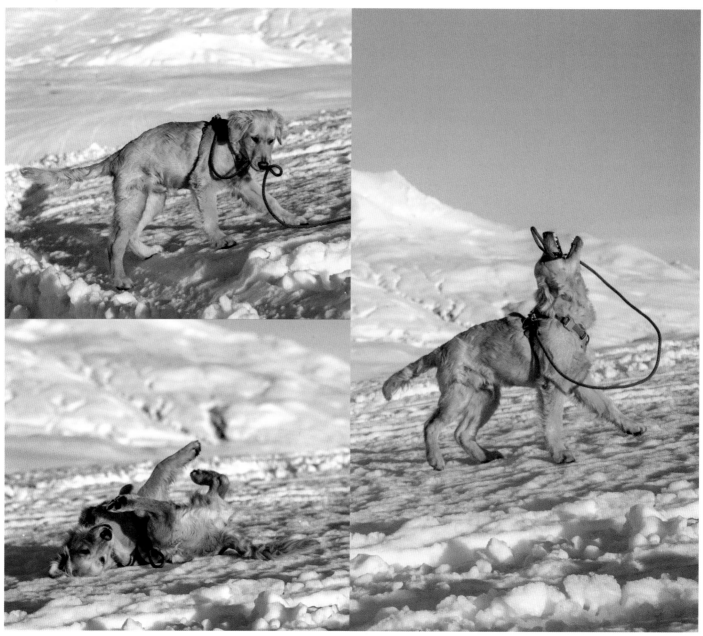

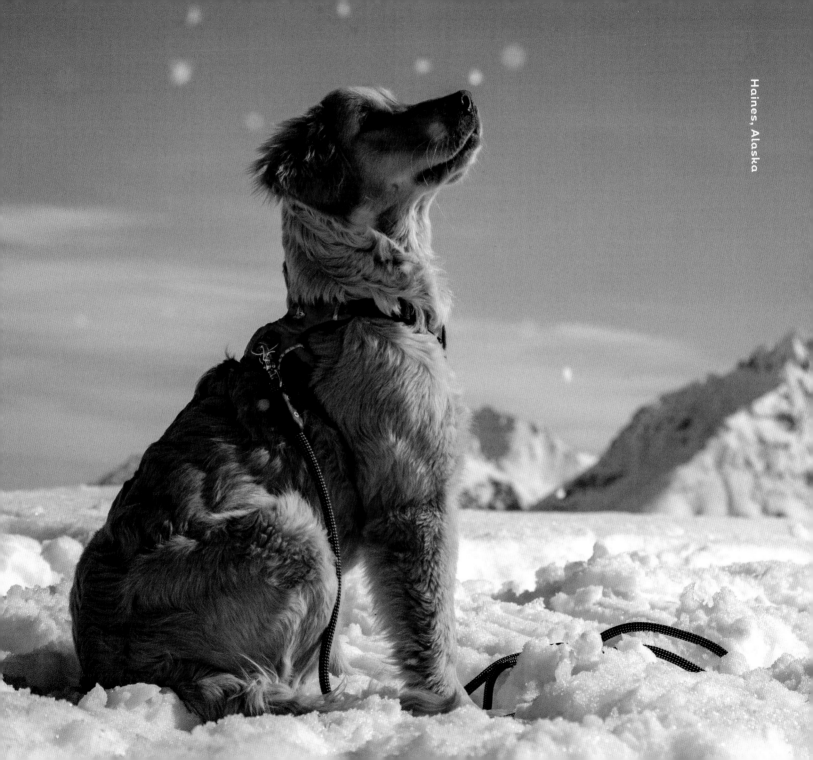

WE MADE IT TO ALASKA, WHICH
HAD BEEN A LIFE-LONG DREAM
OF MINE. AT THIS POINT,
THERE WAS NO DENYING MY
BOND WITH KICKER. HE WAS
SO WILLING AND EXCITED TO BE
PLAYING IN THE MOUNTAINS,
AND HE WAS REALLY STARTING
TO COME INTO HIS OWN.

Haines, Alaska

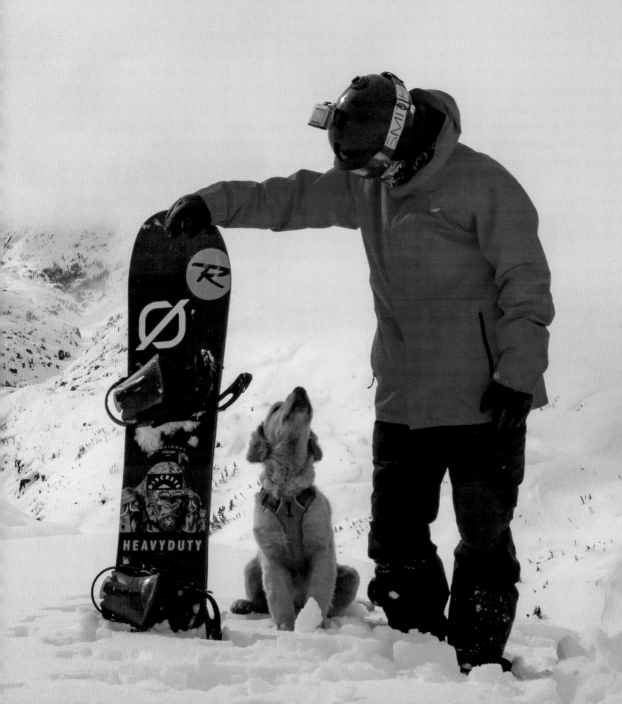

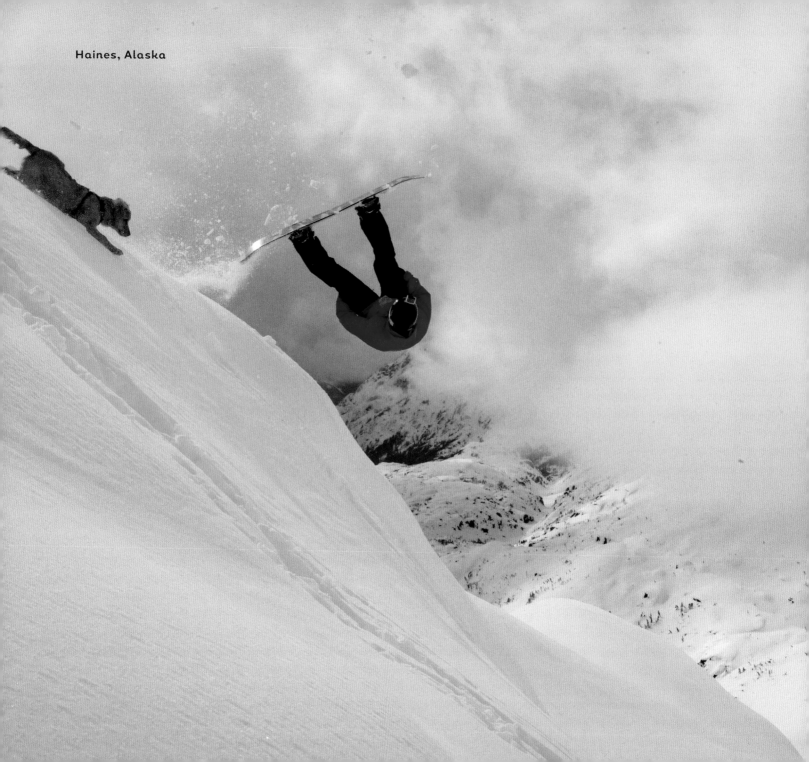

Haines, Alaska

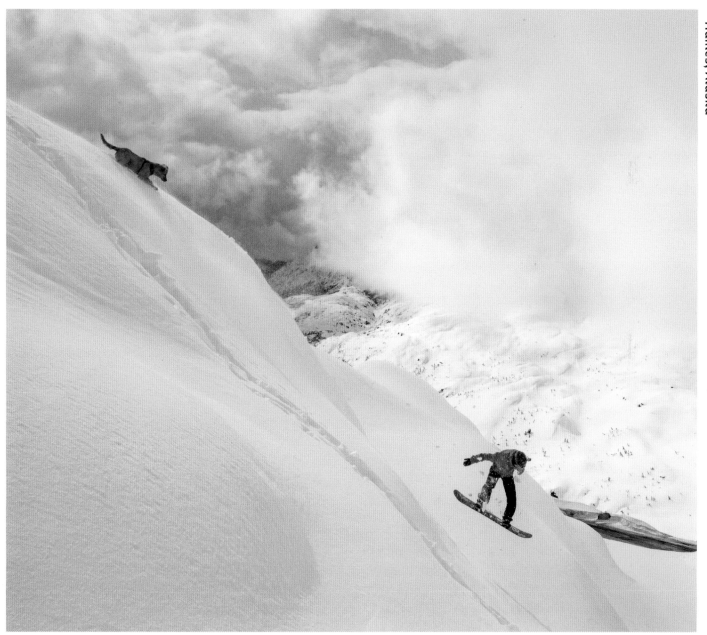

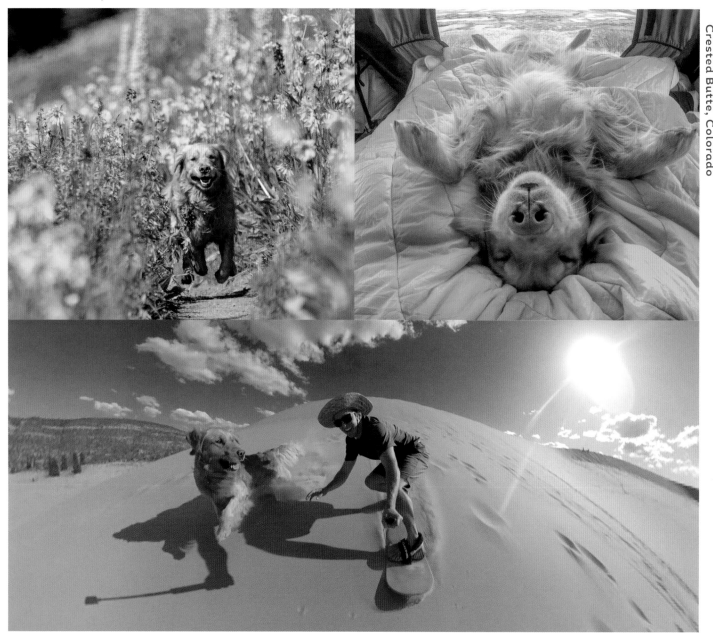

Crested Butte, Colorado

Crested Butte, Colorado

Coral Pink Sand Dunes State Park, Utah

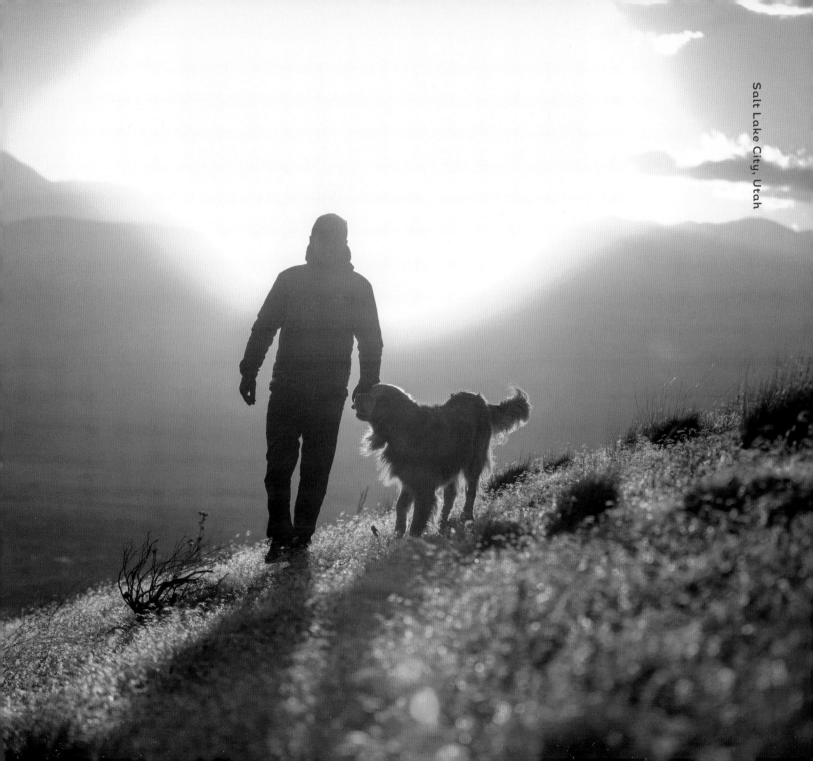

Salt Lake City, Utah

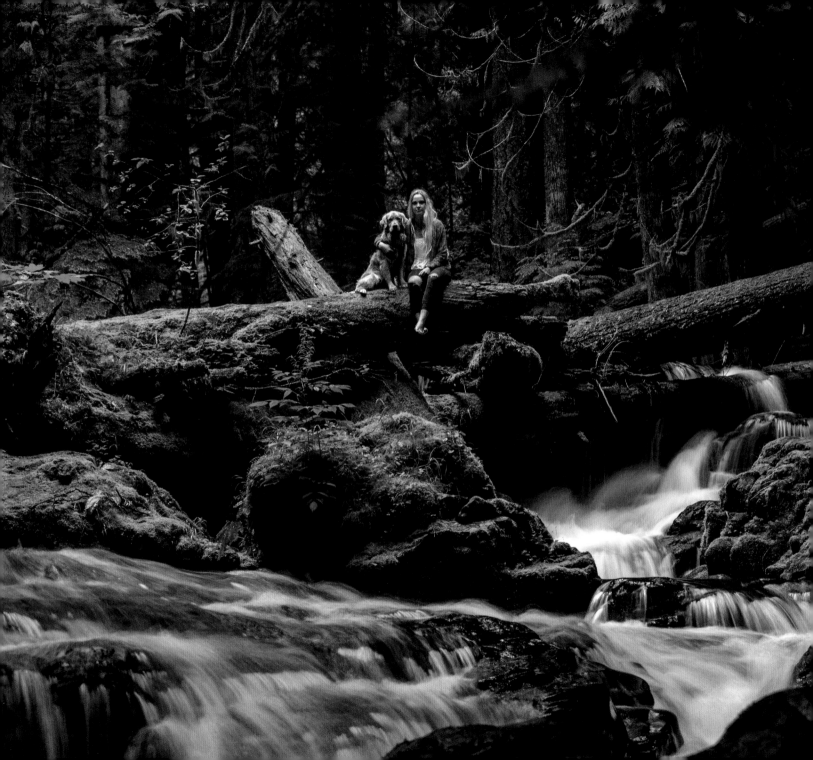

KICKER LOVES TO EXPLORE
AND MEET NEW PEOPLE.
HE'S ALWAYS TAKING IN HIS
SURROUNDINGS AND BRINGING
A BIT OF DOGGY JOY TO
SOMEONE'S LIFE.

Washougal, Washington

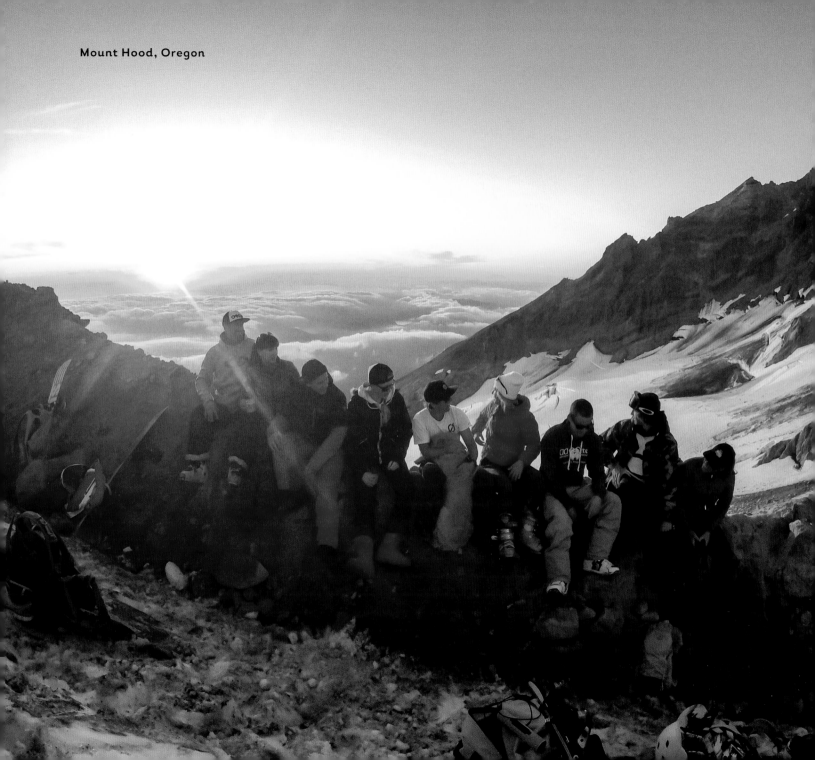

Mount Hood, Oregon

Durango, Colorado

Ding and Dang Slot Canyons, Utah

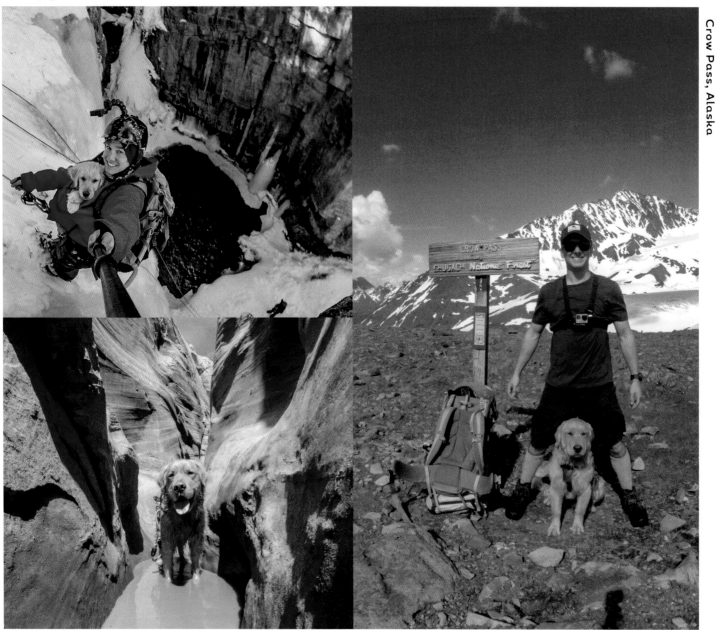

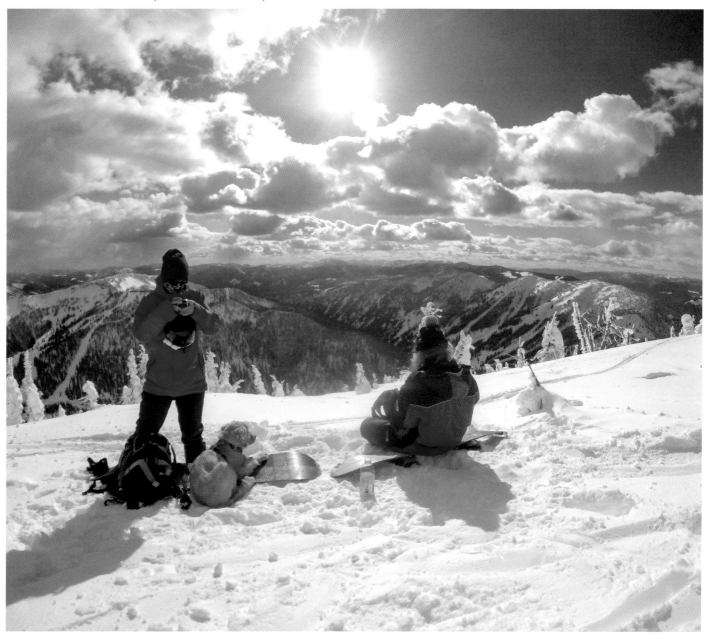

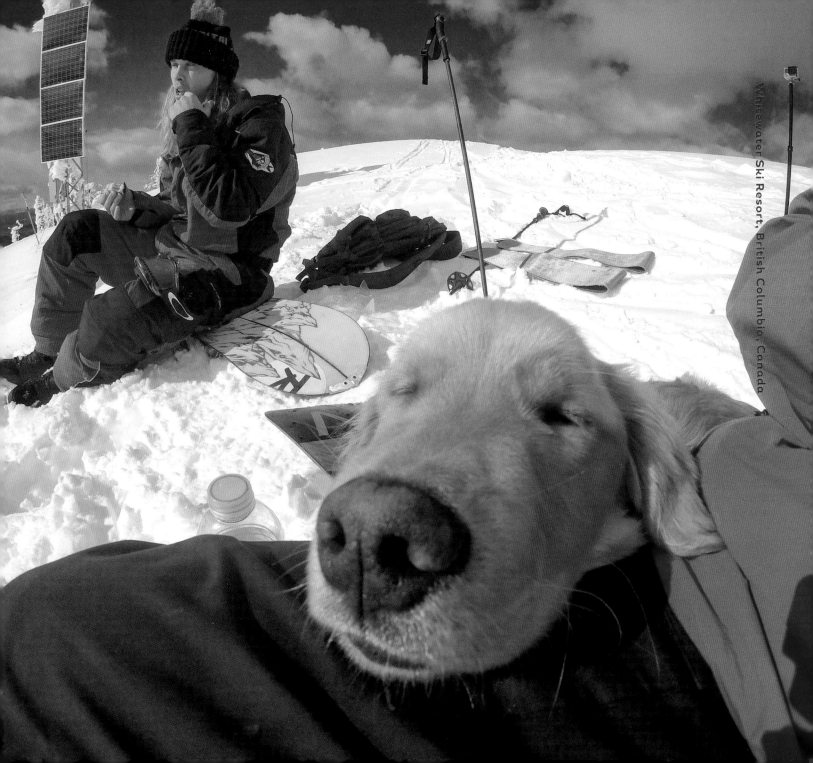

Wasatch Mountain Range, Utah

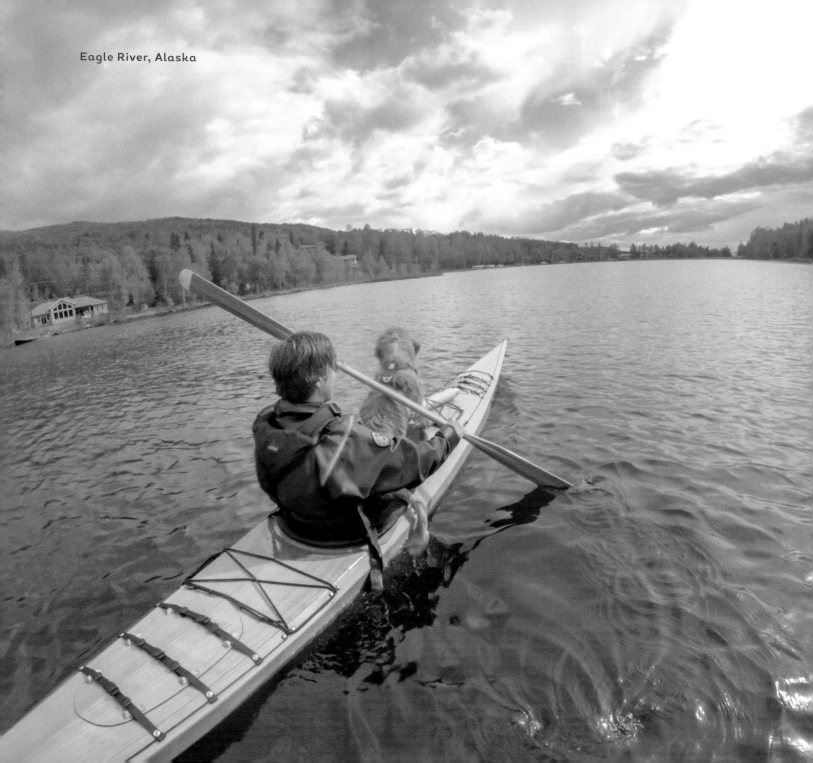

Eagle River, Alaska

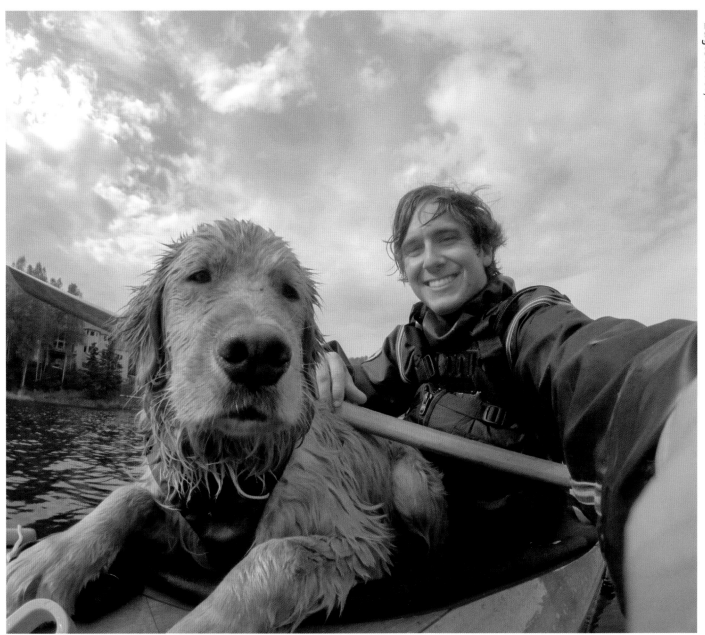

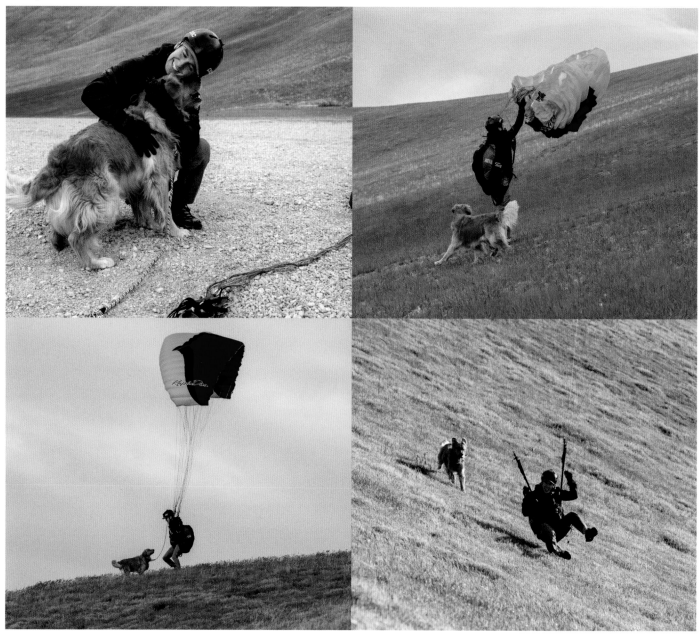

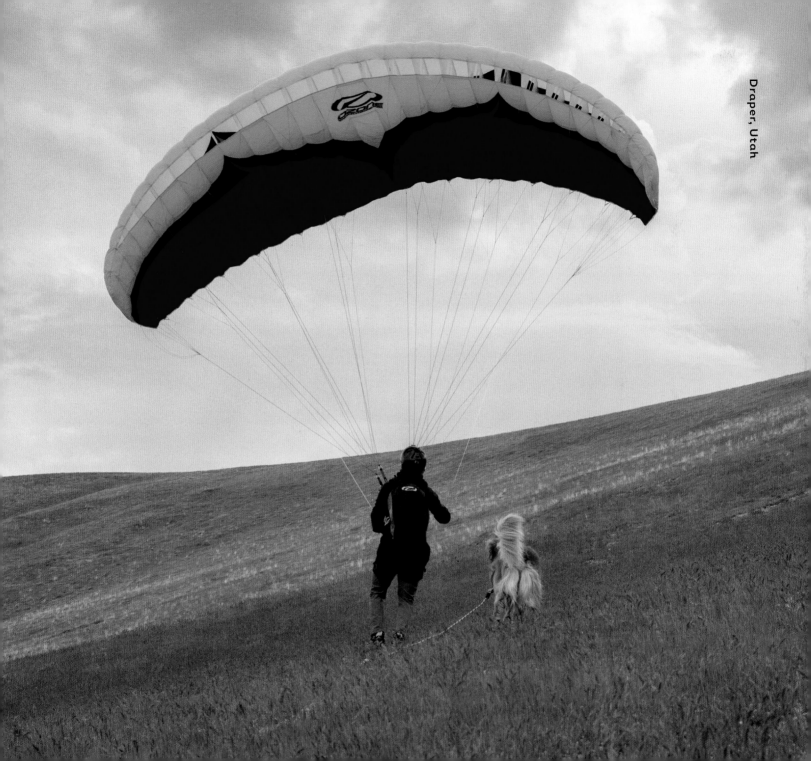

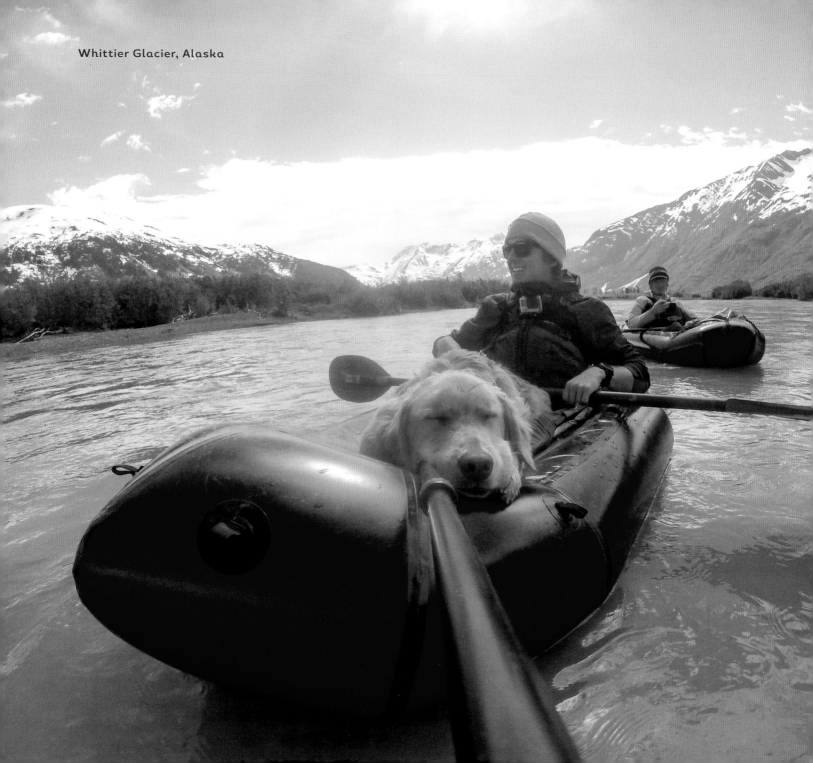

Whittier Glacier, Alaska

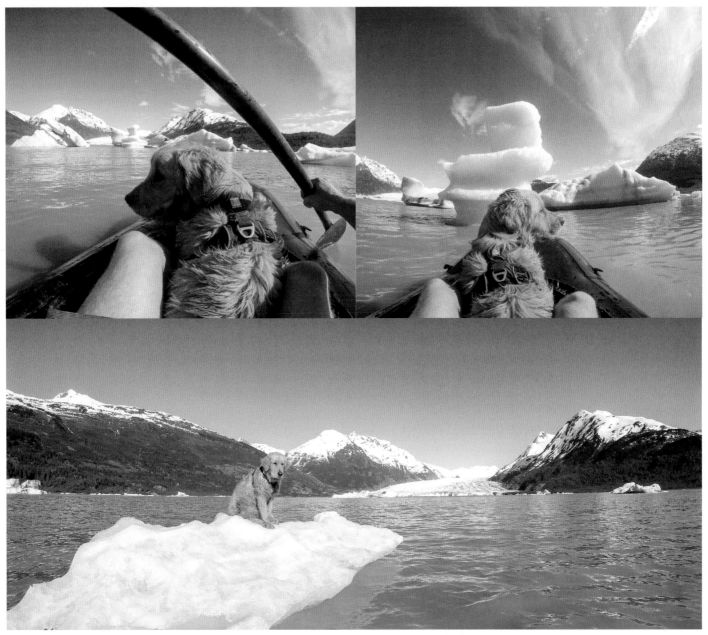

MY FRIEND AND SNOW SPORTS ENTHUSIAST, JENNIE MILTON, STANDS WITH KICKER AT THE OPENING OF A GLACIER ICE CAVE. BY THIS TIME, KICKER'S APPETITE FOR ADVENTURE WAS IN FULL FORCE. THIS IS ONE OF MY FAVORITE PHOTOS FROM THIS TRIP!

Thompson Pass, Alaska

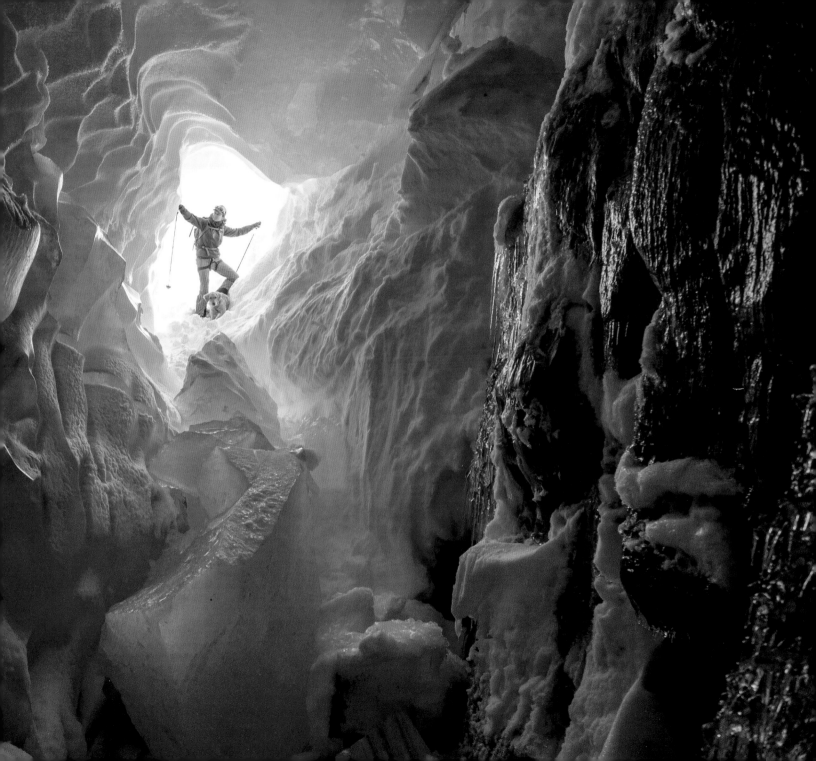

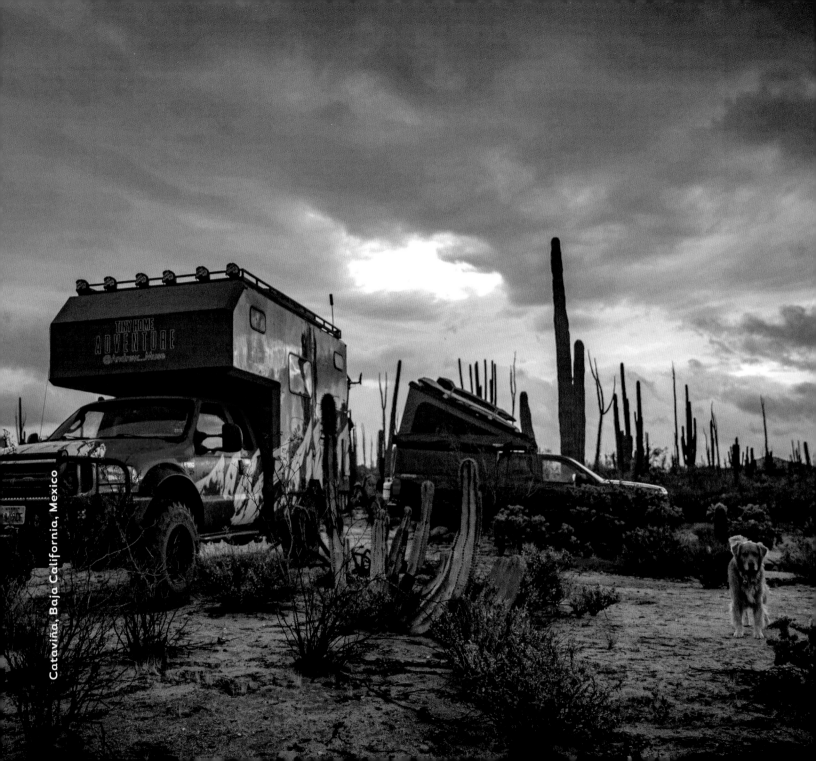

TINY HOME
ADVENTURE
@Andrew_Moss

Cataviña, Baja California, Mexico

BUILDING A
DREAM

Having spent over a decade in alternative living situations in order to prioritize spending my money on experiences, I decided that when I returned from Alaska, I was going to build my dream home on wheels. I wanted to create something like an EarthRoamer vehicle, which is a high-tech, off-the-grid RV that retails for around half a million dollars. However, I was going to attempt to make my own for one-tenth the cost. The plan was to live out of it full time for the next several years while saving up to buy a house.

What I thought was going take three months ended up taking nearly two years, which meant that Kicker became a shop dog for a bit, but I still made a point to go outside with him every day. And whenever he felt like he wasn't getting enough attention, he would find the blackest mud puddle or dankest dead animal to roll around on to let me know that I needed to take him for a proper adventure. We would usually head to

the mountains where we both felt most alive. I'm a strong believer in letting dogs be dogs. For them, there's nothing quite like a life off-leash in nature while they use their instincts and senses to explore. And for me, being forced to break away from my building project was probably the only reason I remained sane—or at least *mostly* sane. . . .

For Season Three of *Tiny Home Adventure*, we set our sails south. If we could figure out how to work effectively from the road, my plan was to spend the next two years heading toward the southern tip of South America in the camper. Right before setting off, however, I broke my leg—and then the COVID-19 pandemic set in. And just like that, our plans were derailed.

When my leg healed and the COVID restrictions started to ease, we decided to head to Baja California in Mexico for three months. Because Kicker is usually a snow dog, Baja was a major change for him at first. He had to learn to adjust to life on the beach and to a layer of salt and sand coating his body, but he came to love it. He spent his days running around in the surf and hanging out with the packs of stray dogs, trying to fit in, which was really fun to watch. When I would go kiteboarding, he would chase me along the shore, and when I went paragliding, he would follow me from below.

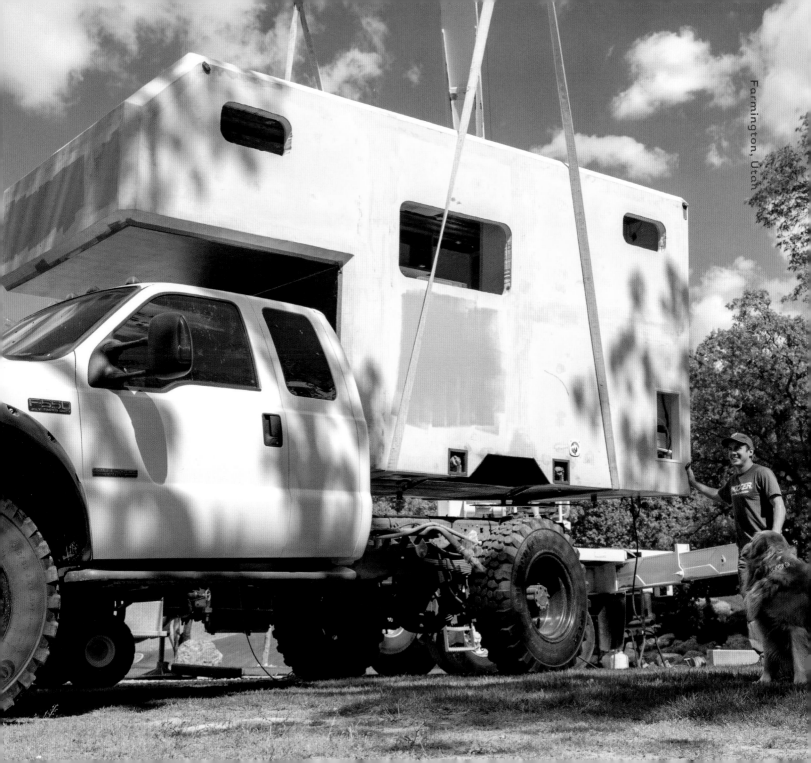

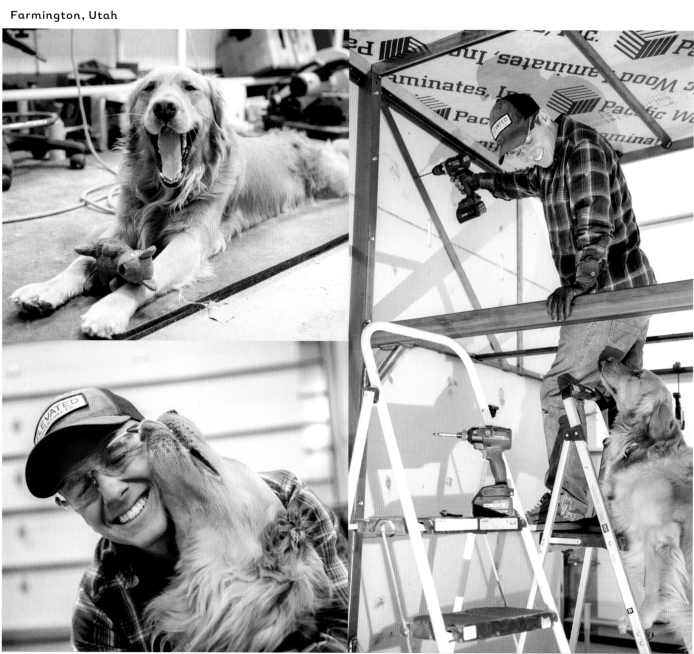

One of my most favorite parts of the trip was getting up before sunrise and sitting just a few feet from the ocean. As the sun would rise, Kicker would do a couple of big stretches before sitting back down at my side and leaning all of his weight into me. (He is quite the leaner; sometimes, if you move too quickly, he'll topple over.) And it's moments like those—the sunrises and the early-morning, sleepy stretches—I know I'll cherish most forever.

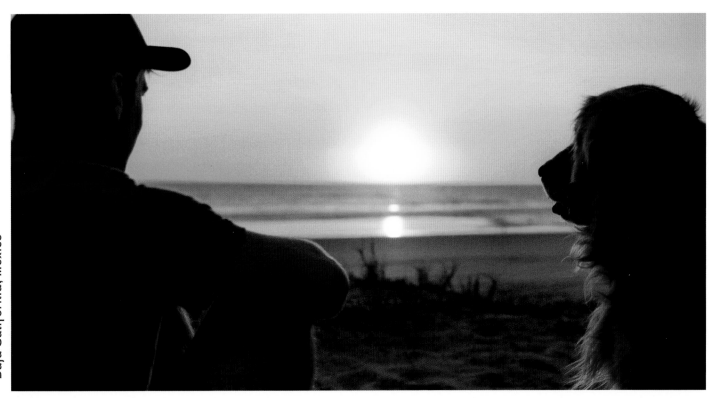

Baja California, Mexico

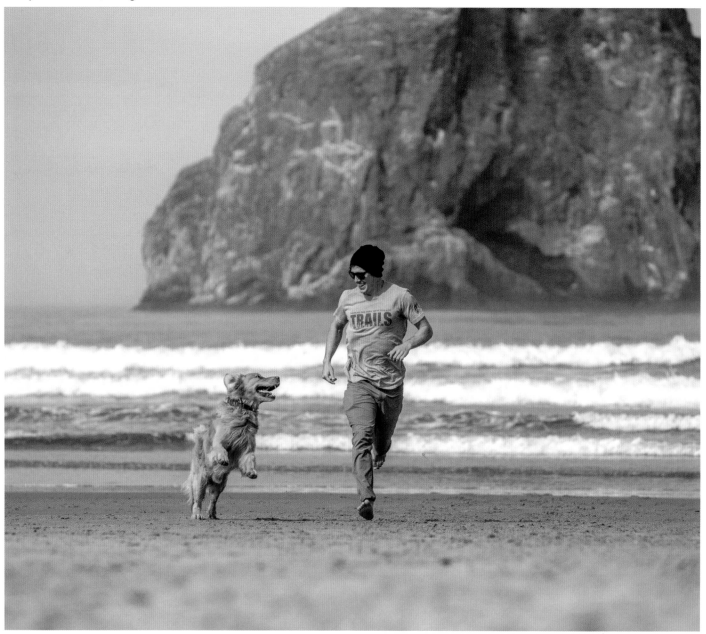

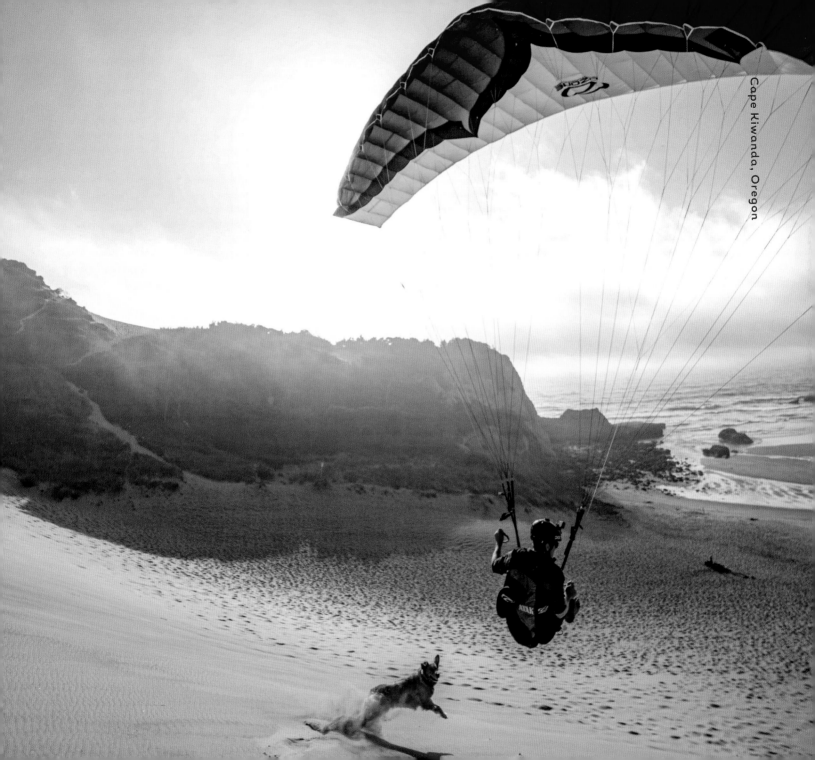

Cape Kiwanda, Oregon

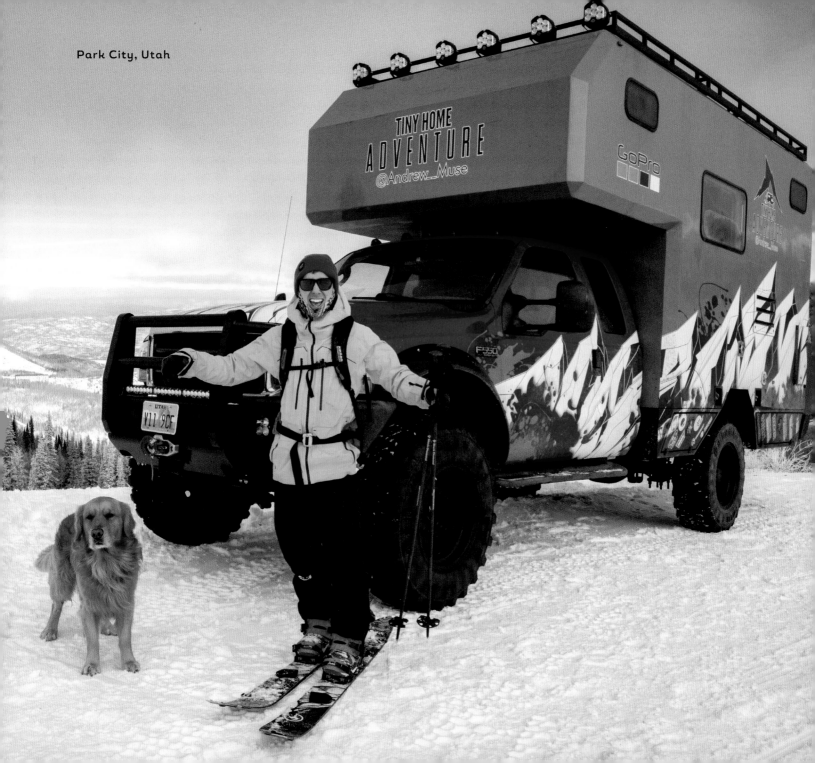

Park City, Utah

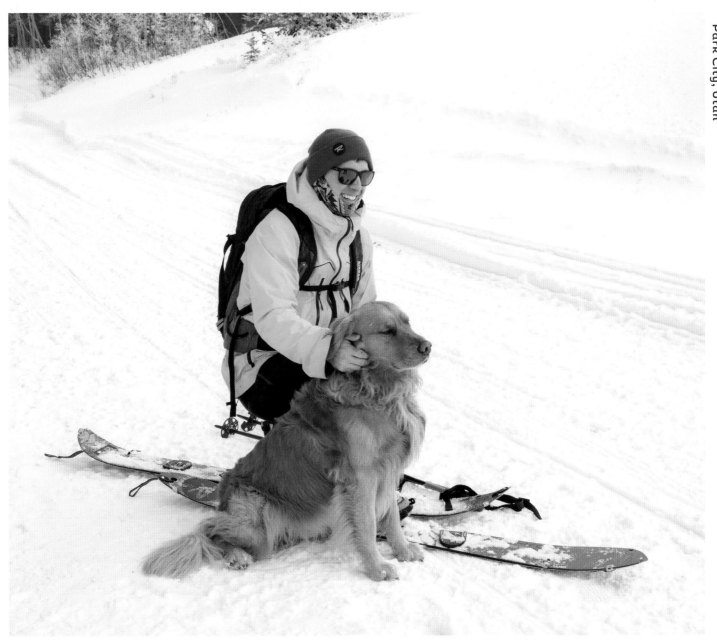

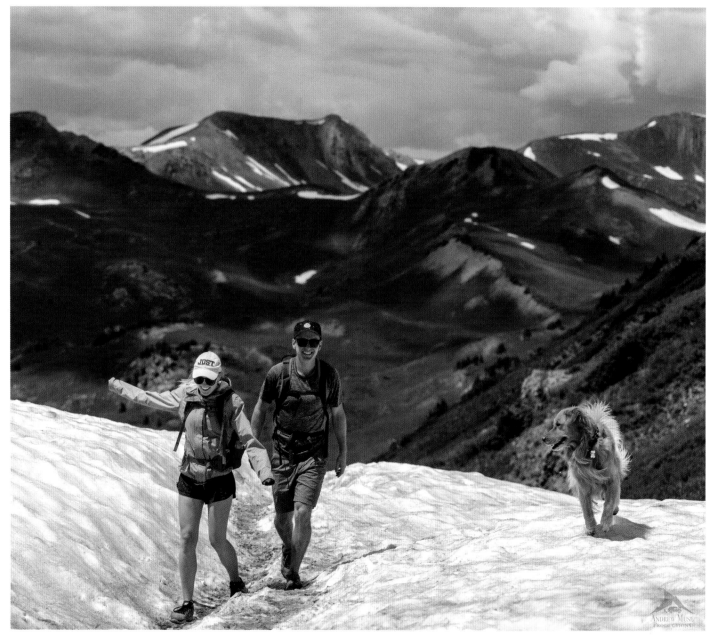

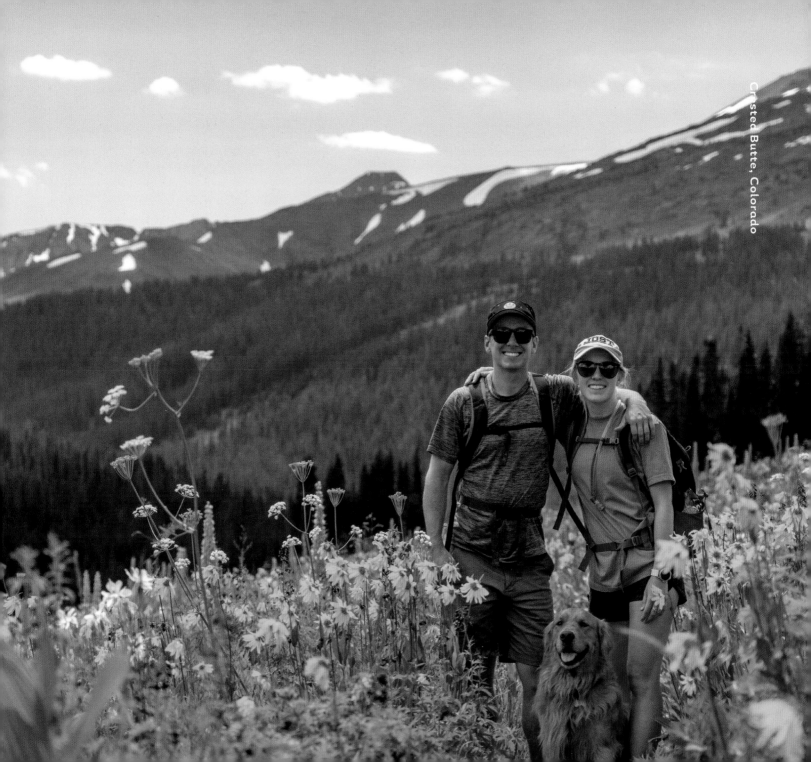

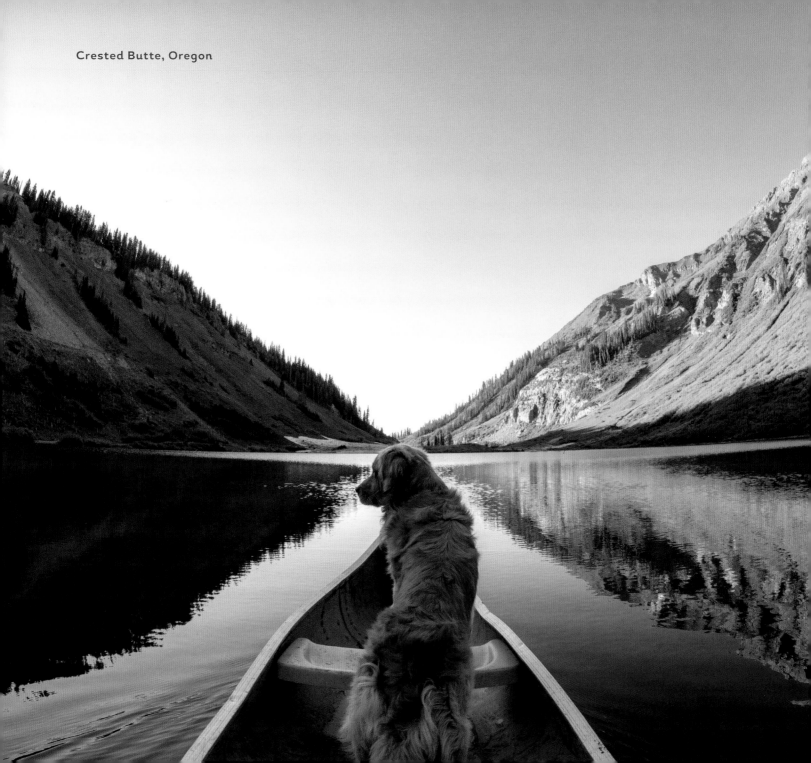

Crested Butte, Oregon

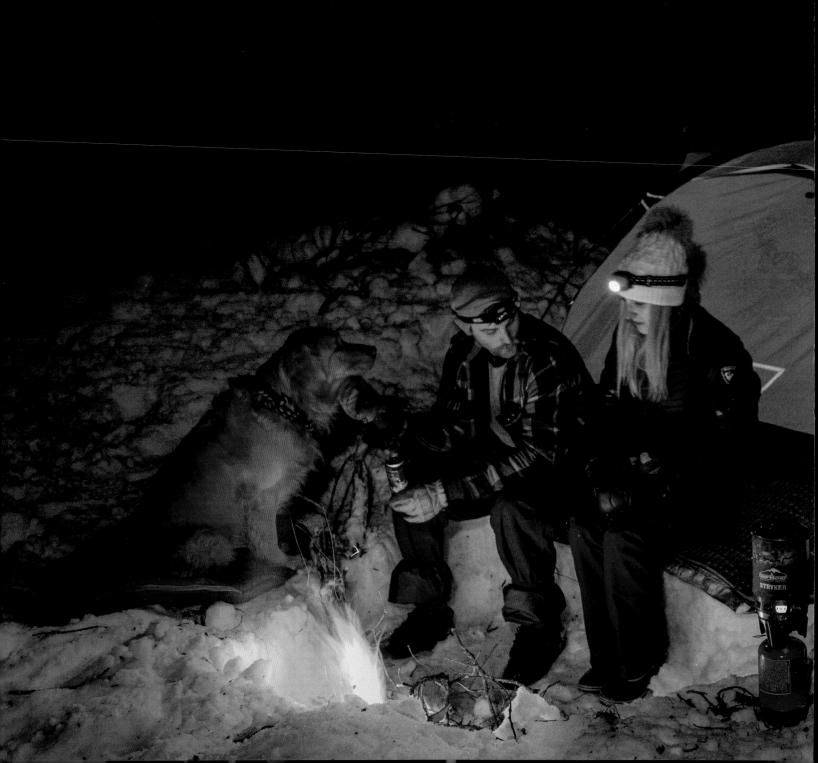

KICKER AND SOME FRIENDS, KEVIN AND ASHLEY, SETTLE INTO CAMP JUST BELOW THE HOT SPRINGS WE VISITED THAT MORNING. WINTER CAMPING IS BEST WHEN SHARED WITH GOOD FRIENDS, GOOD FOOD, AND A COZY TENT!

Spanish Fork, Utah

Moab, Utah

Moab, Utah

Cleveland, Ohio

La Sal Mountains, Utah

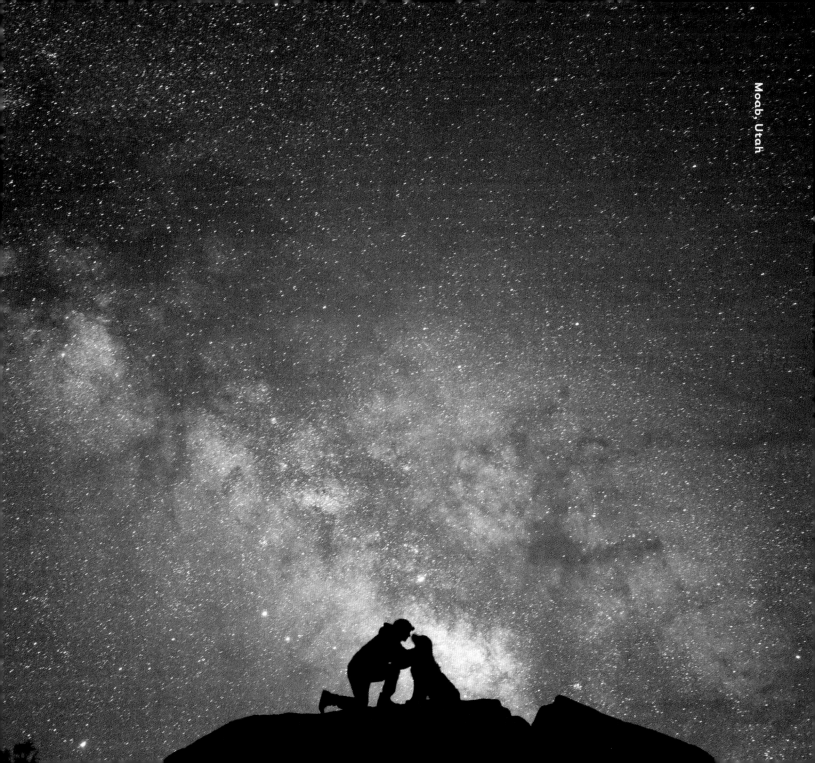

Moab, Utah

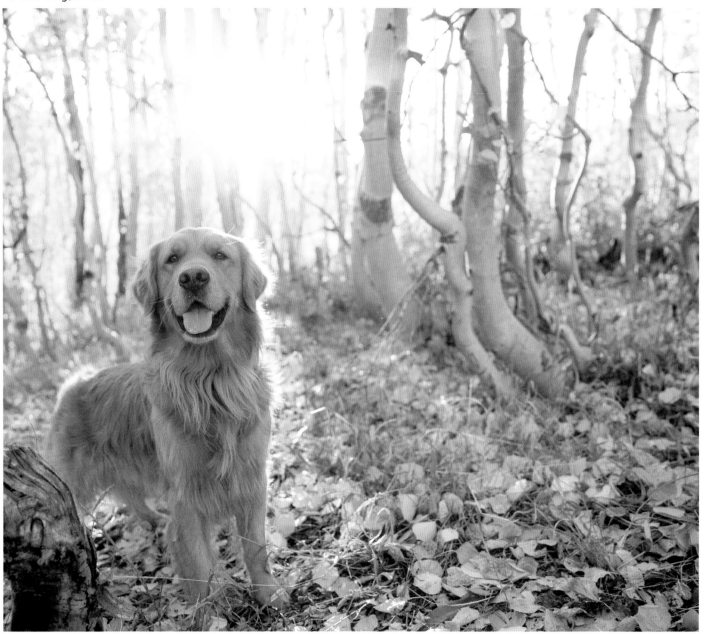

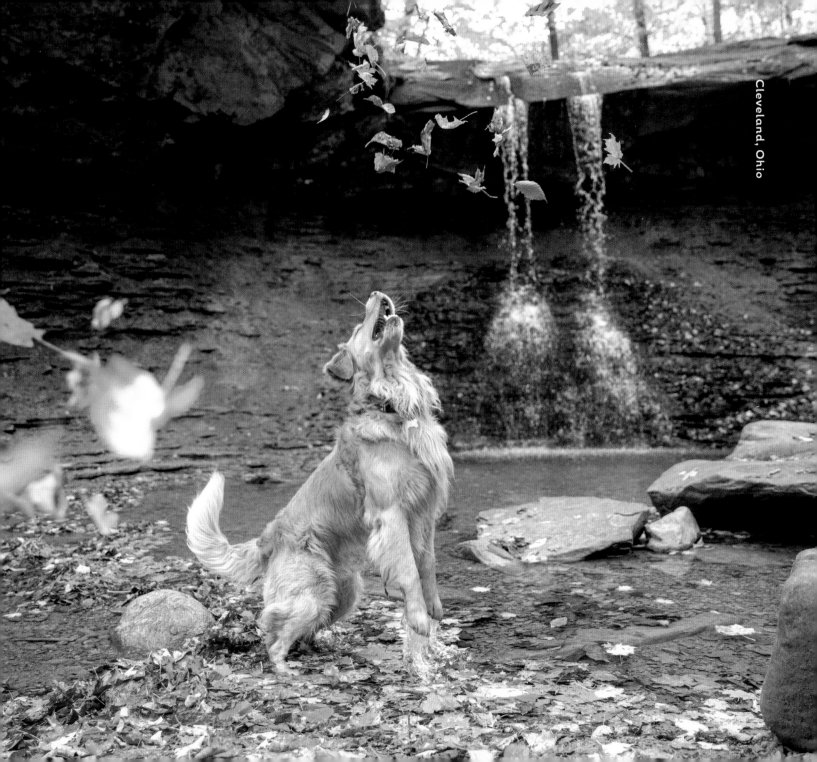

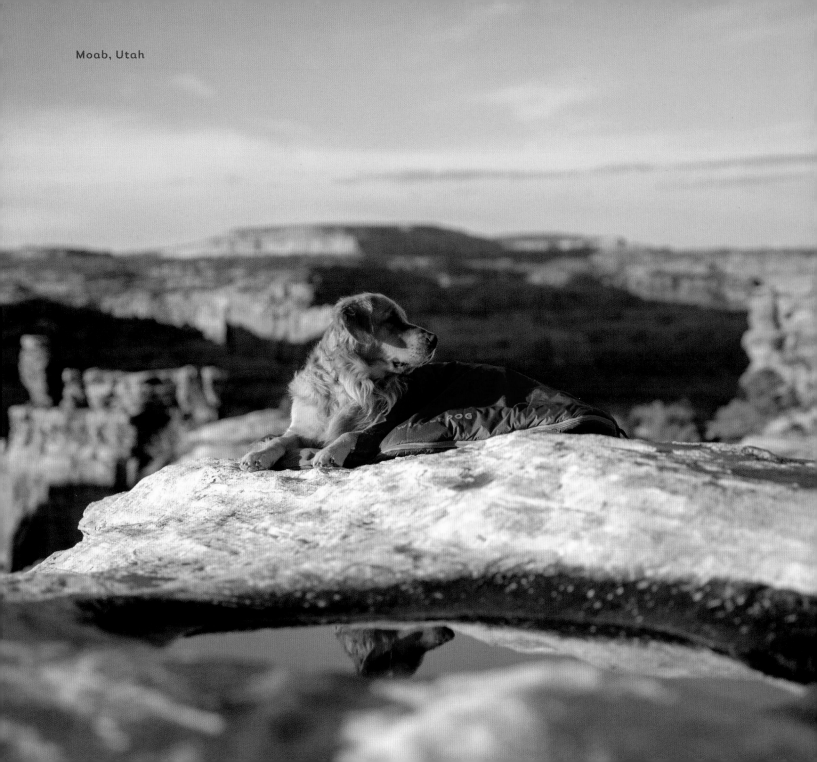

Moab, Utah

Moab, Utah

Moab, Utah

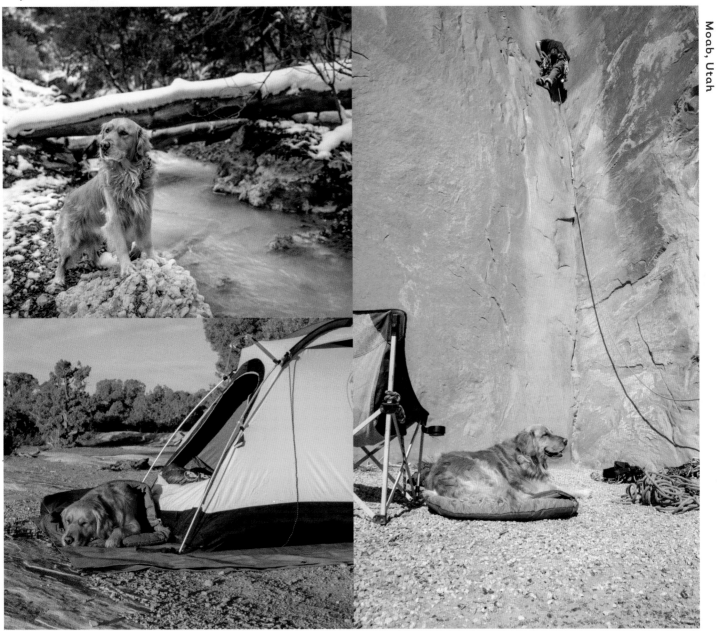

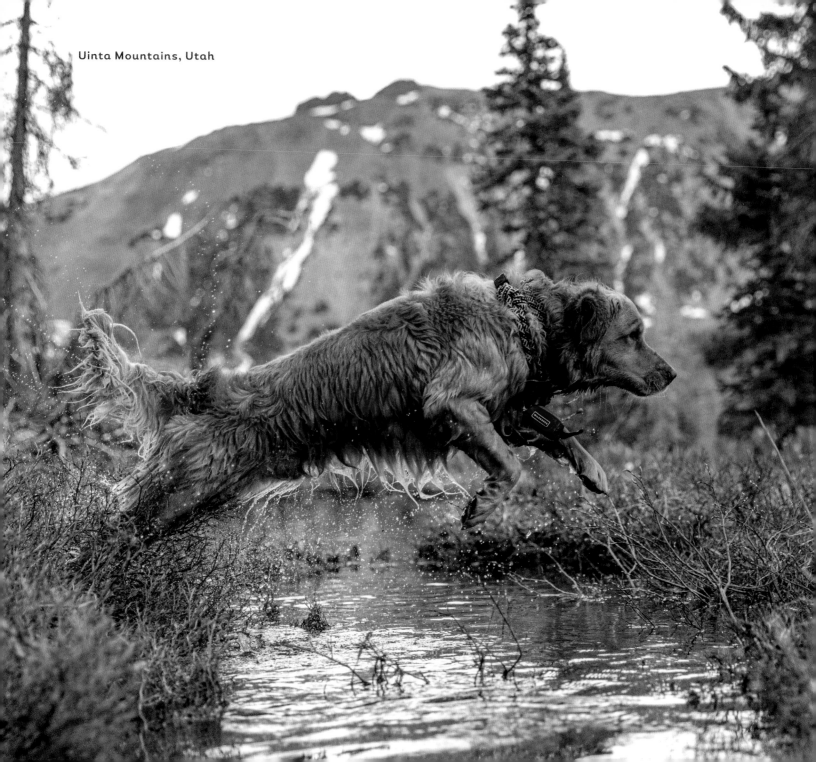

Uinta Mountains, Utah

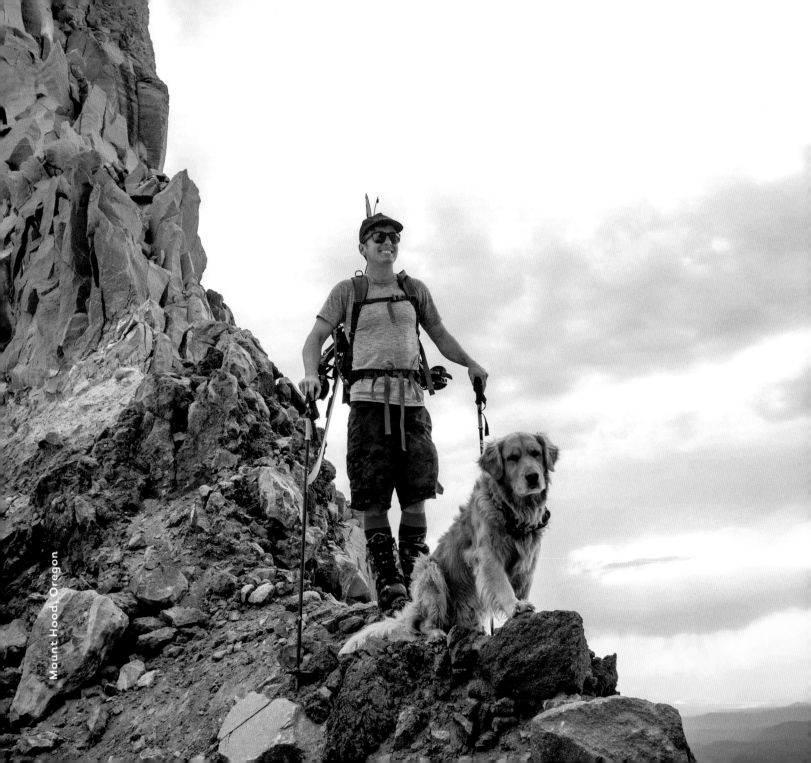
Mount Hood, Oregon

WHAT I'VE LEARNED

Kicker is now five years old, and the bond I felt with Booter is still there, living strong through him. I love him with every fiber of my being, just as I loved Booter.

Having a dog has been one of the most rewarding things in my life. For me, it's about the time spent together exploring, sharing experiences, working through challenging situations, snuggling, and ultimately taking care of one another. Introducing dogs to new adventures and activities early and often—while operating within your own comfort zone to keep them happy, warm, and safe—is vital to feeling at ease with each other on adventures. It's all about building trust, using positive reinforcement, and loving your dog. The love I feel for and from my dogs has filled my soul in a more meaningful way than anything else in my life ever has. And while trying to give my dogs the best life I can imagine, I have lived my own best life, too.

But I've also learned that the loss of a dog is absolutely one of the hardest things you can ever experience. I've pushed myself through the deep, all-encompassing sadness of Booter's loss. I've spent the last five years thinking about my accident, questioning what I could have done differently, what I can learn from the decisions I made, and why I'm still alive. What I could have done differently is simple: I should have pulled over to rest when I was tired. Driving tired is extremely reckless, and I paid a steep price for that decision. From that day, I have learned so many things. Today, I never rush, never put myself in a position where I feel that I have to push past my limit to get anywhere. I have no idea how or why I survived my accident, but if hearing my story can save one person from making the same mistake I did, that's enough of a reason for me.

In addition to that, I hope my story can give hope to anyone who feels they're at rock bottom or that they have nothing worth living for. I want to show people through my adventures and my bond with Kicker that things can get better. You can rebuild an incredible life—one that exceeds your wildest dreams. I am beyond grateful that I'm still alive and that I was able to keep pushing toward my dreams. I am so grateful that Booter and Kicker came into my life. And I am so grateful for all of you.

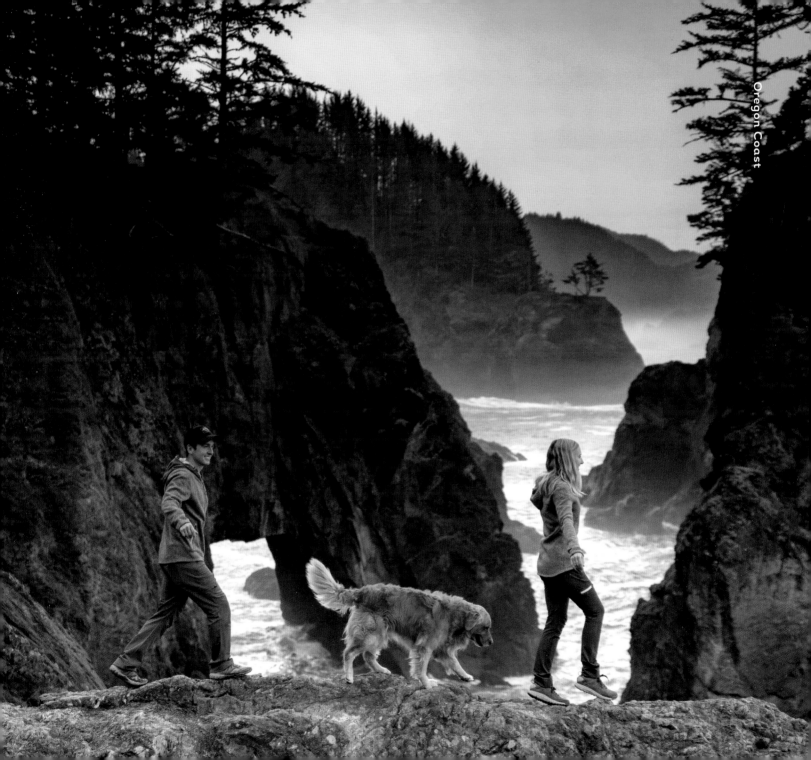

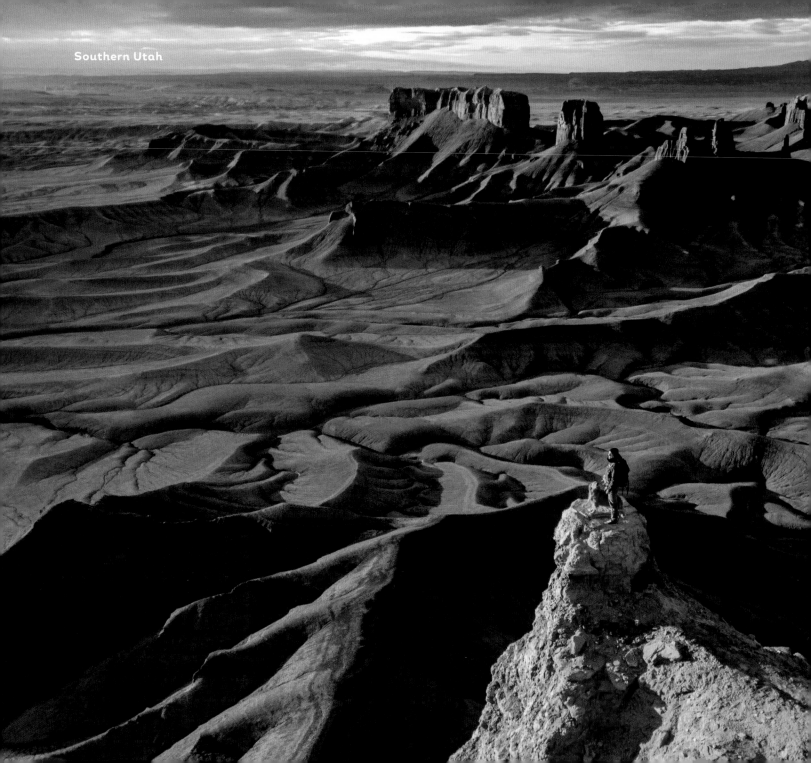
Southern Utah

So, thank you, reader. Thank you for joining Booter, Kicker, and me on this amazing journey called life.

All the love,

Andrew, Kicker, and Booter

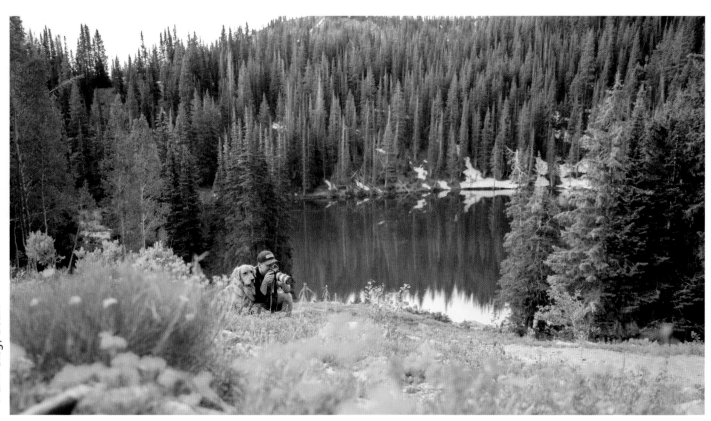

Park City, Utah

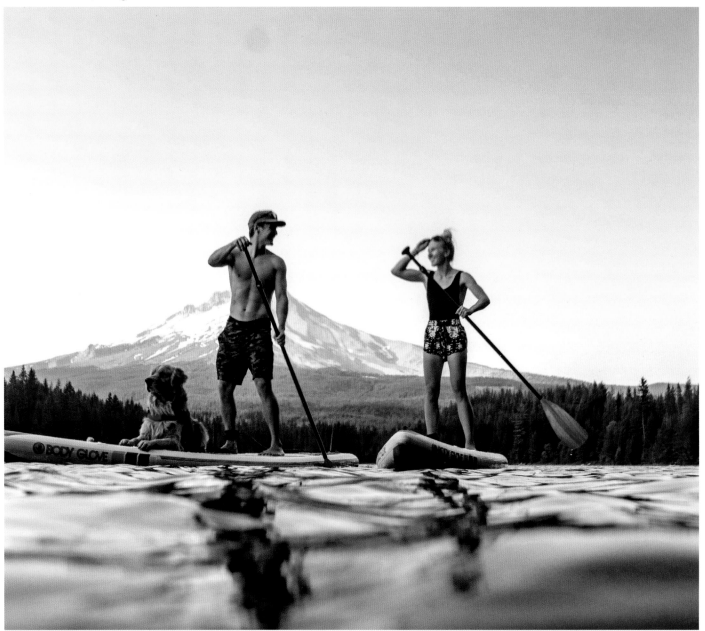

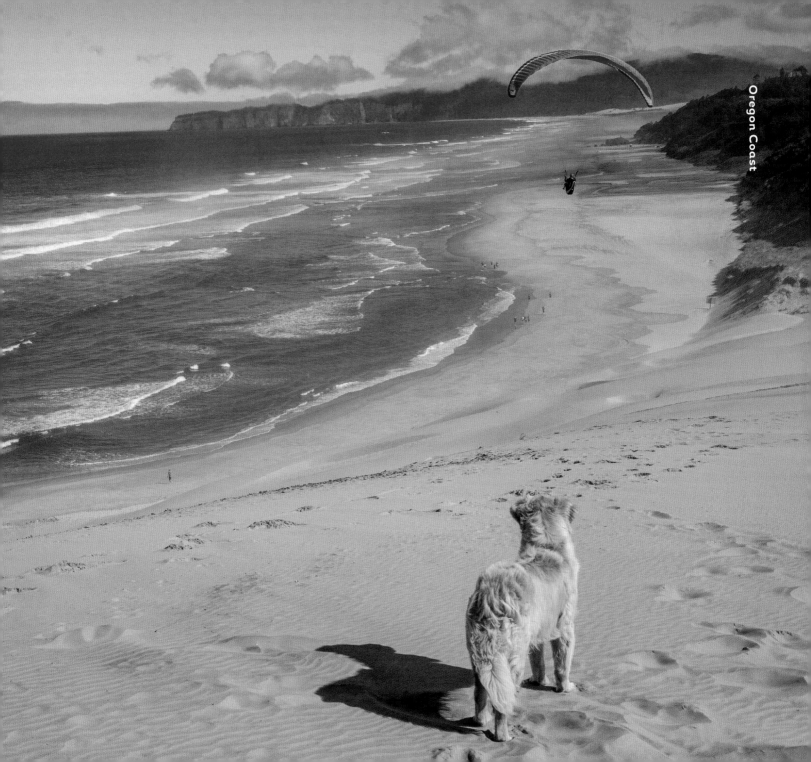

KICKER AND I ENJOYING THE
SUNRISE DURING OUR MORNING
WALK IN MEXICO. OF COURSE,
WE HAD TO GET AS CLOSE TO THE
WAVES AS POSSIBLE.

Baja California, Mexico

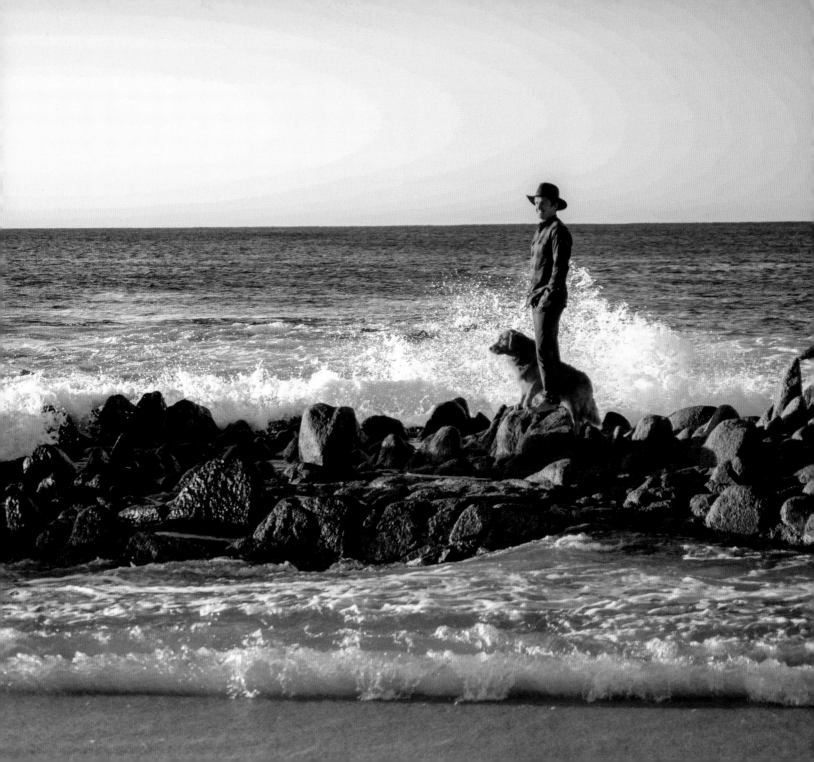

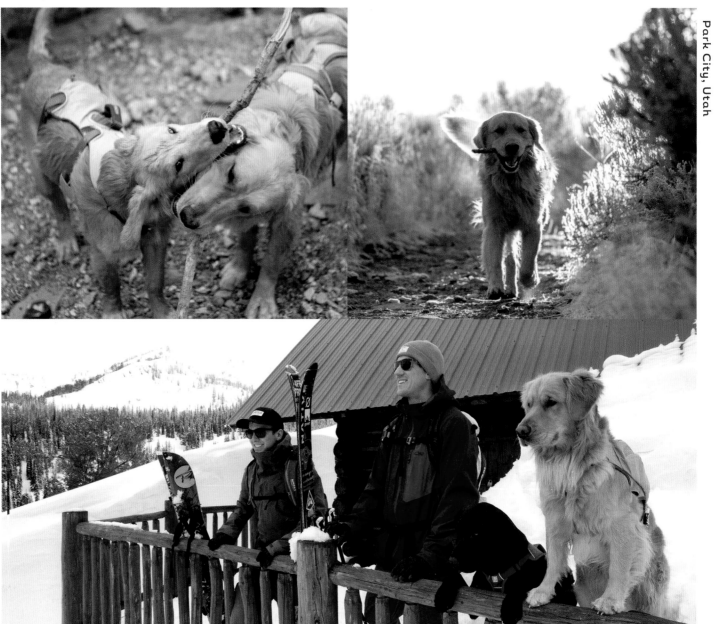

Moab, Utah

Park City, Utah

Sawtooth Mountains, Idaho

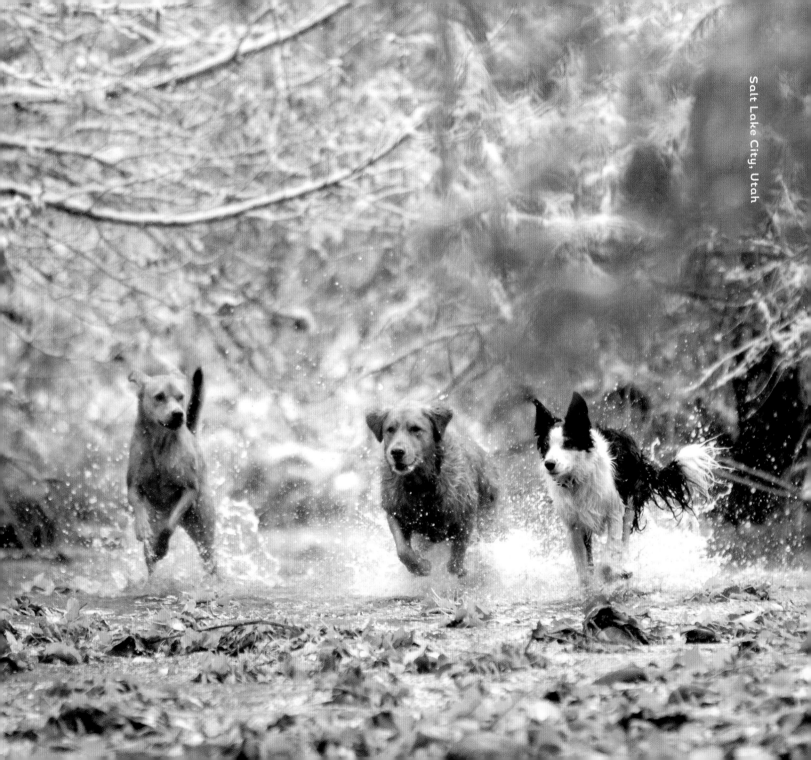

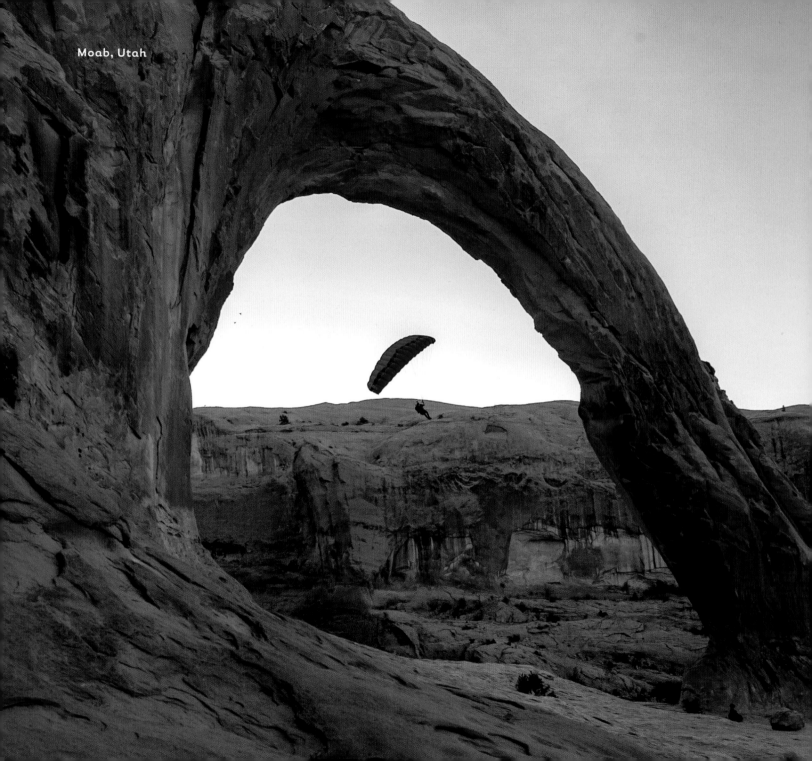

Moab, Utah

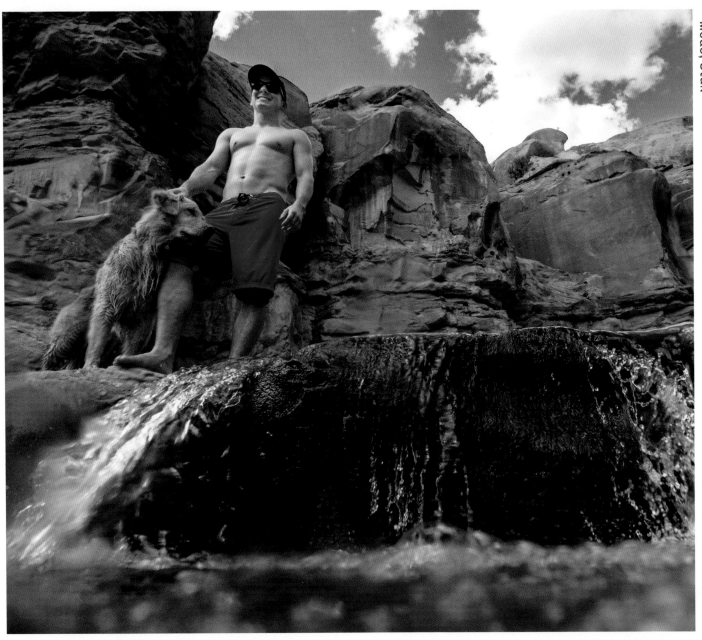

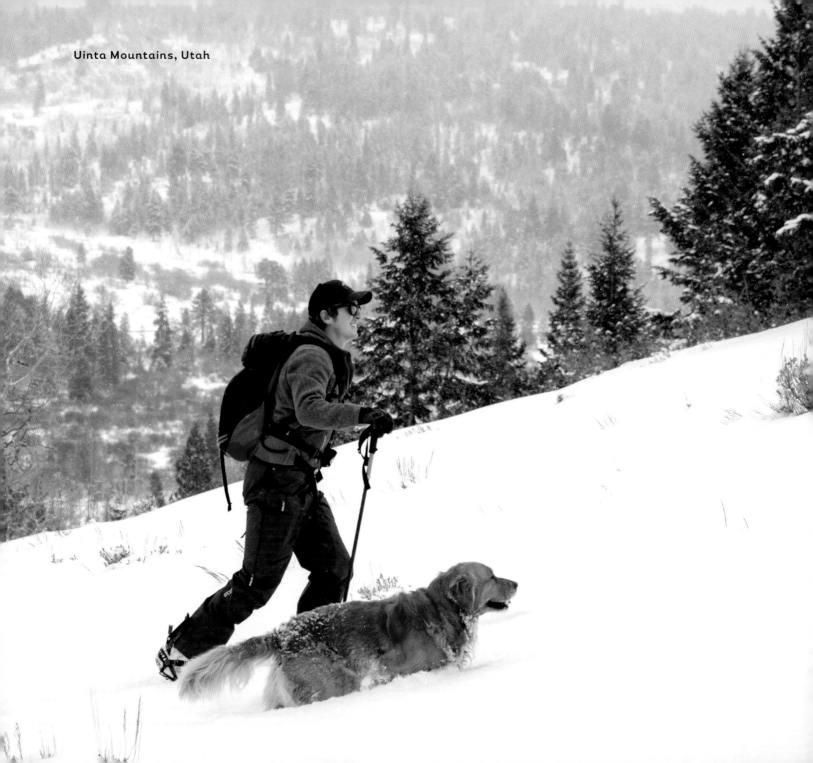

Uinta Mountains, Utah

Hood River, Oregon

Moab, Utah

Park City, Utah

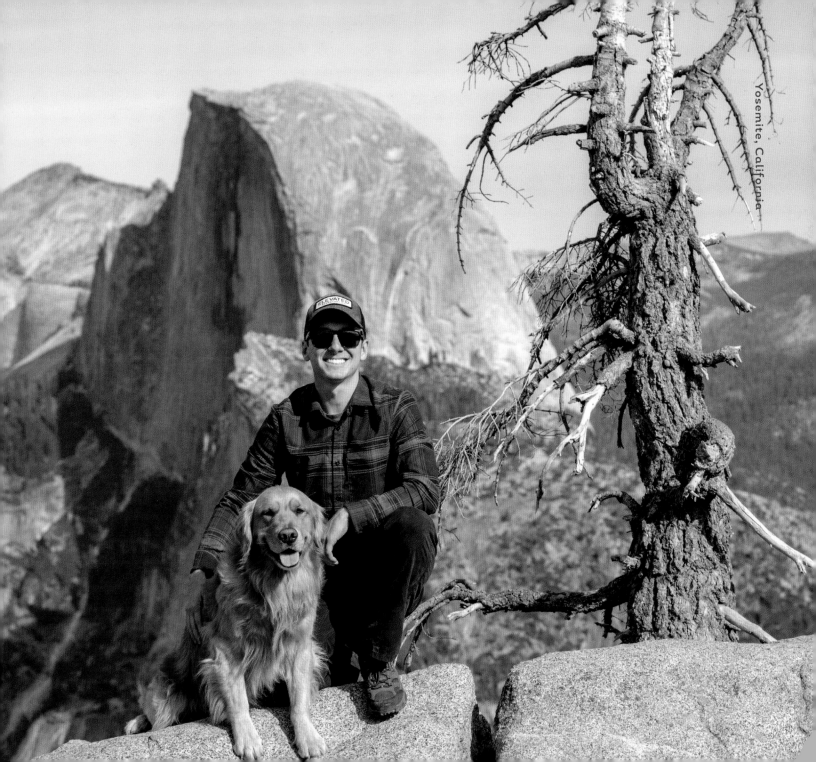
Yosemite, California

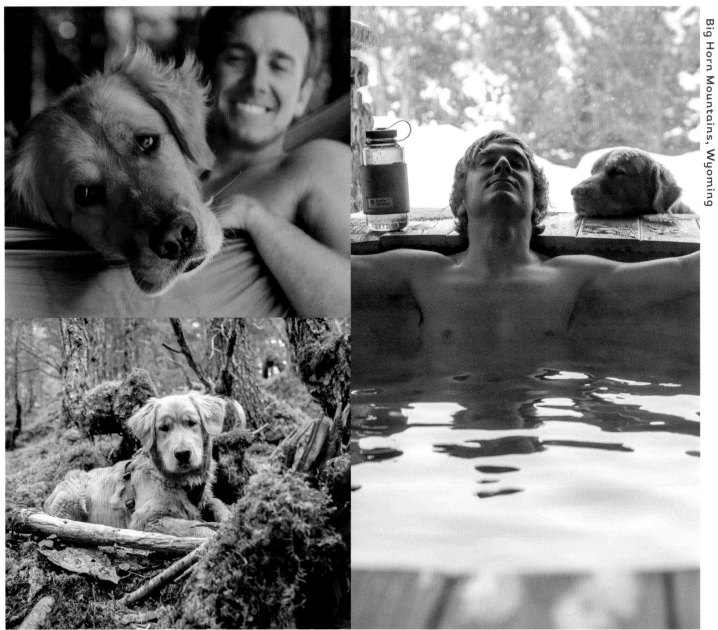

Trillium Lake, Oregon

Big Horn Mountains, Wyoming

Girdwood, Alaska

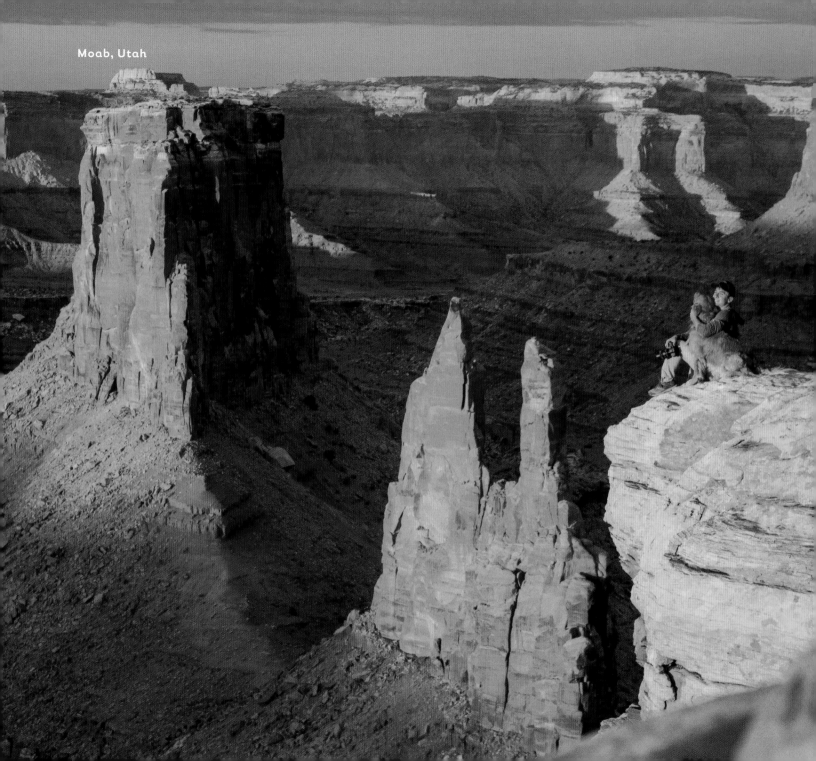

Moab, Utah

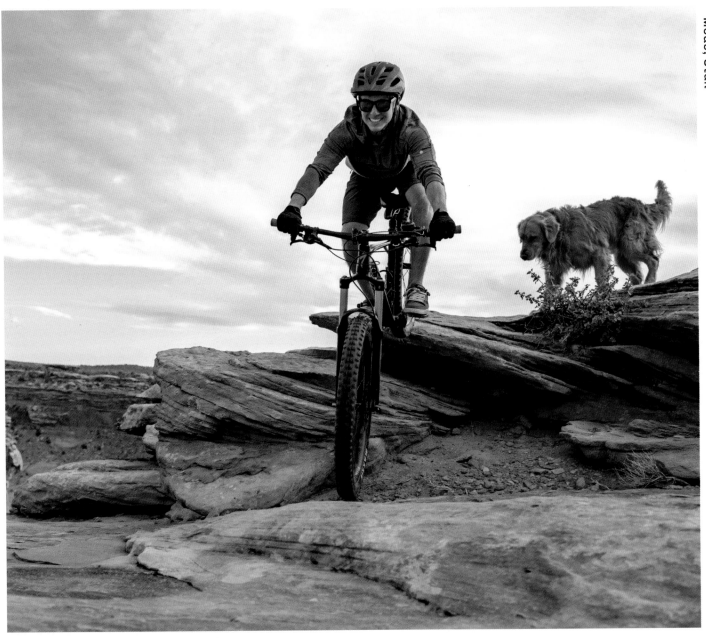

Hanksville, Utah

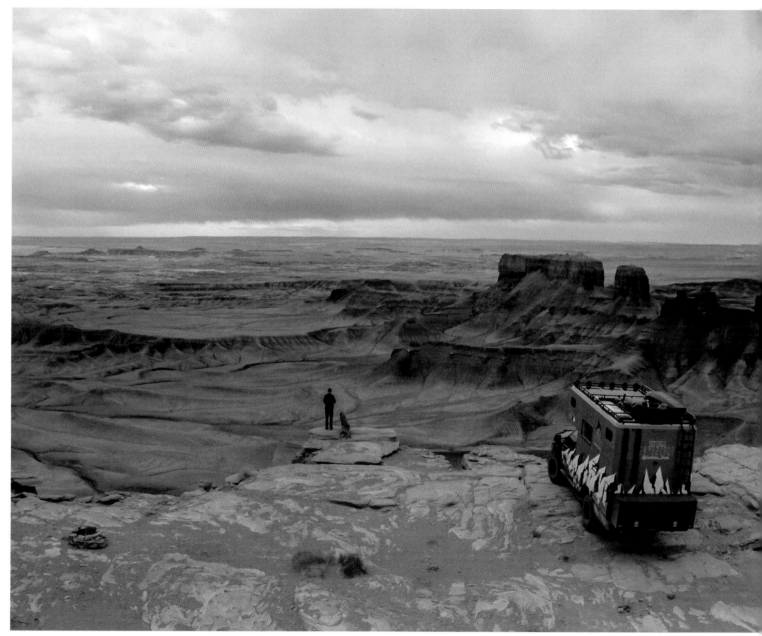

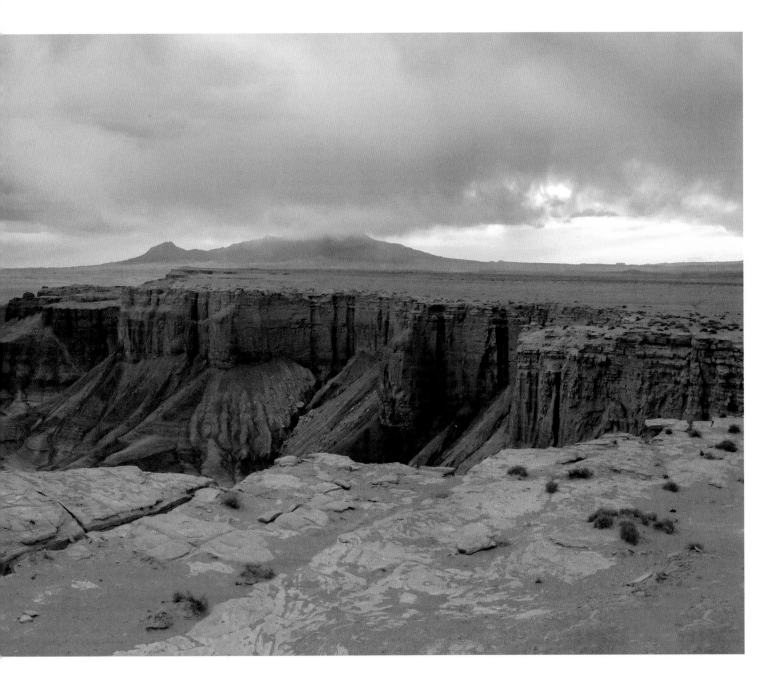

ACKNOWLEDGMENTS

This simple truth is that I would not be here without the kindness of people like you. The kindness of people who helped pick me up when I was down. The people who believed in me. The people who told me to keep going. Who told me that the way I lived inspired them to keep pushing through their own hardships or gave them the courage to chase their own adventures. My life has surpassed my wildest dreams, and I owe it all to you!

Special thanks to:

Nate Dolin-Aubertin

Paul Arnold

Janie Arnold

Emily Arnold

Red Canyon Retrievers

Copper Canyon Doodles

Paragonah Fire
 Department

Josh Heiner

Ashley LaMarre

Graham Anthony

The Wards

Colin Green

Lululemon Park City

Brad Plowman

Maverik

Tom and Haley Lebsack

Rossignol

Alex Stoy

Tina Nardi

Charles Lapage

Aaron Kawkak

The Haugens

GoPro

Phil Matteini

Erin Edenholm

Abe Kislevitz

Davey Smidt

Brix Casserly

The Heiners

The LaMarres

Liam Pickhardt

Croshane Hillyard

Mark LeBlanc

Elizibeth LeBlanc

Devin Di Peitro

Jo Savage

Peter Quale

Wellness Pet Food

Zesty Paws

The US Ski Team

Colby Aneglos

John Wright

Donna Dupont

Ashley Halligan

Kathy VanWeelden
 Barss

Tara Miller

Matt Rosene

Kati Wasserman

Ruth

Markus Gaupp

Matthew Barron

David Lodato

Priscilla McInnis

Nancy Negron

Joe Haugen
Meg McDonald
Ashley Turner
Warner B.
Lindsay McGuire
Maureen Campbell
Gina and Kyla Cooper
Yulia Dubinina
Carlyn Aarish
Christina Lynch
Amber Lind
Amanda Stern
Stephanie Nachtrab
Katherine Dougherty
Leslie Kerr
Emily Summers
Jake Weber
Kyle L.
Luciana Salmi
Rachel Dieterle
Thon's Family
Chris Straface
Erik Thomsen
Nancy
Abbi Lathrop Martz
Raul Keally
Lee Gordon
Nikki Flanders
Darcy Culverwell

Travis Littledike
Camille Kirkpatrick
Christine Dolan
Scott
Janice Greaves
Ryan Kilpatrick
Lisa Mizushima
Rob Aseltine
Brandon Munson
Jessica Estrada
Jessica Bolton
Elizabeth Fish
Jane Reichlen McGarry
Nikki @
 deeganthedogplus2
Mike Packer
Dave Hodgson
Abby Gennaro
Christophe Stuck-Girard
Casey Hague
A. Jensen
Jasmine Ardeshiri
Joe Knuepfer
Trevor Rzucidlo
Mary pat Lowe
Abby Taylor
Jonathan and Joy
Rebecca Waitt
James Hill

Lisa Slagle
My Dude
Jamie Esposito
Delphine C. Edouard
Robyn Cage
David Drouin
Cecelia Ercolino
Jordana Meilleur
Erin Spear
Paul Thibedeau
Dylan Ferguson
Debbie and Stevan
 (Seth's mum and dad)
Meehan
Liz Buckler
Marcus Llewellyn
Jennifer Parrish
Jess King
Talmadge Hicks
Michelle Rock
Maggie Warner
Charles
Jeanne Havdoglous
Stephanie Lussier
Stacey Brogan
Jesse Cervantes
Tess Reichlen
Matt Carbone
Kira Repici

Kelsey Howarth
Rocky Maloney
Meghan Graham
Abbie Batchelder
Dana Clarfield
Jessica Borsje-Clark
Tesla Burton
Peggy Wilkie
Jeremy Dorson
Anna Sideri
Alex Kirkwood
Mason Marino
Krista and Khemist
 van Parys
Maureen H.
Joethekiter Mullen
Rick
B. Lui
Nick Wilson
John and Lisa B.
Clemens Jezler
Trish French
Georgina Dawson
Parasaran Raman
Anita Ruslander
Katlyn Holland
Matt Willett
Erik Snyder
Amy Knollinger

Tara R.
Jay Dash
Andrew Godaire
Jared Lagemann
Riley End
The Winn's
Madison Holmes
John Strenio
Ethan Cline
Burggraff Family
Mairin
Oakley's Mom
Maximilian Nickou
Pete Iannitto
Cullen Connors
Noel Minneci
Alex Pollock
Mike Agricola
Teresa Ruminski
Davis Dewey
Sarah Roazen
Lindsay Malone
Seth and Betsy Meehan
Miles
Callam Gaddis
Luke McCartney
William Towne
Antea Gatalica
Bronx

Bill Day
Rich Romero
Kaitlin Alexander
Ryan Gallant
Maggie McGreevy
Hilary and Amy
Allison
Alexandria F.
Pam and Jim
 Franciscovich
Micaela Purcell
Katherine Brandt
Amy Richie
Courtney
Paul Naddaff
Steve Dalton
Peter Van Dyke
Natalie
Taryn Johnson
Michael Ettinger
Abby Szach
Desiree Touchette
Ashley and TJ Lanning
Julie Miller
Alex Lefty
Matt Wells
Gene Bradfird
Nikki and Simon
 Bedingfeld

Allison Yeary Cesati
Brad Crete
Jenny Badger
Chris Liddell
Keaton Robbins
Louise Fletcher
Cole Lehman
Thomas Purcell
Brett Shirley
Gabriela Cordova
Charley Kramer
Cassi Migliorini
Jonathan Brown
Abby Brown
Jimmy Jaksic
Matt Dombrowski
Bjorn Eriksen
Megan H.
Eric Witmer
Kyra Downing-Krepela
Lauren Adario
Emily Wiswell
Ranell Shea
Elizabeth Bartlett
Jordan Fox
Megan Linehan
Heather Linehan
Alex Cohen
Robert Troup

Becky and Brandon
 Smith
Graham Sours
Kasey
Robert Falkowski
Terence Omalley
Lara R.
Sergey Fedotov
Eli Peterson
Chyllene Newell
Caleb Noble
Sparky Harden
Andrea Herber
Sandra Winter
Christi Brown
Uncle Jerry
Sam Everett
Clay Moncrief
Doug Emerzian
Faith Clarke
Erik Raymond
Andi Goldberg
Rich Madeley
Shad Coulson
Fordy
Duffy Comeau
Lara Wiesmann
Luz Diaz
Celeste Rhoads

Travis Nelson
Melissa Cronin
Kip McFarland
Cassy Meyers
Andrew Barton
Sarah Farrell
Adam Quinn
Katie Barker
KC Oakley
Jess Arnold Arnold
David Bauer
Kevin Bloss
Daniel Croft
Jayne
Mike Walton
Justin Martin
Trevor Torreele
Dan Miles
Derek Thomson
Christina Harostock
Jennifer Kiesznoski
Portia
Brad Gordon
John Brennan
Matthew Buranich
Kim Bunning
Lesley Kushner
Cori McDaniel
Jessie Sharp

Wayne Phillips
Katelyn Schoof
Nick Knecht
Veronica OLeary
Dustin Clark
Jessica Fine
Ran Yehushua
Ted Drass
Christin and Nick
 Van Dine
Scott Turbide
Mark Johnson
Reece Larsen
Katie Devlin
Jillian Kinter
Jim Stringfellow
Kiera K.
Kim Kaminske
Maggie Jones
Brock Butterfield
Andy Parsley
Isaac Albrecht
Stephanie Riedl
Peregrine Bosler
Trent Zimmerman
Michael McGann
Ben Hunt
Jennifer Sayre
Marcy Bradley

Humbolt, California

Kyle Losik
Cat Clark
Ashley Plante
Matt Gordon and
 Adrienne Kapalko
Valery Behr
Colin Green
Mason Caccia
Kara N.
Nancy Norcross
Georgia Todd
Jessie Balicki
George Pare
Pete Garceau
Sharon Eastman
Sara Towne
Emma Odell
Richie Brady
Andrew Terrell
David Spinowitz
joeybean
Ariel Cox
Izzy Galland
Kristopher Reslow
Claire Wiley
James Reichlen
Erik Tibbits
The Haddocks
April Bowe

Andre Shoumatoff
Denise Andrews
Anne Timpson
Michela Finnegan
J.R. Montes
Ang Lucisano
Cameron Benner
Casey Sowul
Maria T. Fernandes
Cori Romenesko
Anna Taylor
Hunter Meakin
Michelle McKenney
Samantha LeBlanc
 (Allen)
Brittany Kinter
Jen Doherty
Dan Jarmolowicz
Harris Family
Angeli VanLaanen
Adam Salmi
Michael Matejka
Kiah Fiers
Marley Wright
Luke Whittle
Leanne Pelosi
Chip Rich
Michael Matejka
Deb Kerr

Jared Winkler
Ferris Salameh
Amanda Burggraff
Kirk Terashima
Anthony Del Vecchio
Sail Schechter
Lindsay Havdoglous
Heather McCormack
Will D'angelo
Kim Carleton-Kmiec
Kyle Avery
Christian kirkland
Brad Gallant
Chad Spector
Tori Broughton
Brittney Gadd
Gerry LeBlanc
Shannon Runyon
Sarah McMahon
Sarah Hawkins
Natalie Colvin
Chloe Davis
Laura Troiano
Michaela Hares
Bryce Sacks
Kyle Crisham
Jon Duda
Gareth Van Dyk
Megan O'Malley

John Rossiter
Blake Pelton
Andrea Toth
Katelin St. Peter-Blair
Andrew Connor
Anthony Saylor
Mel Campbell
Kelli Kneeland
Nate Bird
Phylicia Kuchar
Jeff Dickson
Sonia Giffney
Lindsey Wennerth
Eric Curtis
Taylor Wasson
Claire Ranit
C. Edward Brice
Annie Naylor
Morgan Ferrick
Bailey Meade
Alyce Pollock
Colin Batchelder
Ty and Kristin Dolan
Kevin Dupre
Chris Pearson
Karyn Jacobsen
Julian Carr
Nicole Griffin
Alex Deckard

Erin pollock
Lissa N.
Heleena Sideris
Lydia Rupnow
Sara Baumgardt
Christina Tinucci
Stacey Robinson
Aidan MacDonald
Alex Reid
Mike Metzger
Skdy ADMIN
Meghan McKinney
Justin Haaga
Sam Noertker
Gregg Beckett
Charles Puff
Tim Burniski
Christopher Kuczek
Angela Buege
Matt Alemany
Elaine O'Malley
Kimmy Sharp
Brian Stephens
Sarah Flinn
Megan McCormick
Tim Phillips
Chelsea Holmes
Patrick Saucier
Brendan Moore

Meagan Knowles
Jay Trombler
David Peck
Ally Bebbling
Mary Christa Smith
Christine DeMello
Beth Warner
Megan Briley
Troy Tully
Breaonna McClure
Tori Sowul
Kevin Rapf
Greg Pilkington
Nehali Dave
Alicia Stockman
Anna Marno
Kira Spencer-Marengi
Cathy Muse
Emme Wistrom
Dean Marengi
Lindsay Price
Ed Lewis
Cassie Anderson
Sharmali Kulatunga
Rachel
Casey Cook
Wendy Weaver
Natalie McHale
Katie N.

Bronwyn Denard
Jackie Perron
Kathleen Frame
Molly Provost
Tayah Norris
Matt Pelletier
Tyson Malchow
Kristina Sandi
Moon Mountain Man
KC Clark
Kirsten Pierson
Anne Saunders
Jane Warnock
Sam Richardson
Fernando Rivero
Farah Rieker
Saori Barlow
John Lenhardt
Alice Derry
Georgina Smith
Chili Billy Weeks
Taryn Rice
Ron Crowther
Daniel Chun
Brad Hansen
Brandon Sullivan
Tracy Joseph
Bill and Kelley
 Adventures

Erin
Ivars Purvins
Jonathan Parsons
Dave Mathias
Edwin Chau
Matt Shaw
Jon Michael
Overlanding_With_
 Aussie
Ben Bigler
Matthew Ruehl
Kelsea Perkinson
AJ Mannarino
Mike Hobbs
Martin Chenicek
Amanda Zablocky
Kristin Sanger
Lucille
Zach
Courtney Hubert
Evan Jackson
Bison Overland
 Campers
Joe Mustone
Dave Pickhardt
Mitch @dirtroad_mobbing
Seth VanSpeybrock
Derek Robinson
Nancy J Szejbach

Daniel Magee
Xavier L.
Sherri Bradley
Kim R.
Cory Thurmond

Jennifer Langille
Scott Barlow
Dylan
Berto
Kris Del Rosario

Larry McMaster
Lisa Martin
Tabb Adams
Danielle Forsyth
Cache S.

Lisa Mandelin
Craig Lester
Ryan Matthes
Nick Sauer Hansen
Roxanne Saucedo

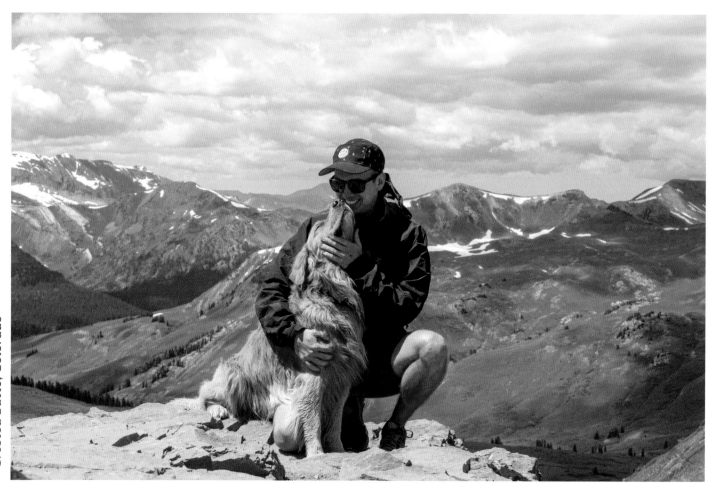

Crested Butte, Colorado

Deidra Shafer
Kaleigh Hannigan
Tadas Narbutas
Cajsha White
Larry
Neka Latimer
Lucas Saltz
Skyjay Galli
Evan Chandler
Joshua Pepper
Levi Nichols
David McKee
Teri Hartshorn
Janik Voth
Kimberly Olinger
Alexis Larson
Nero2017
Venessa Ramirez
Becky Smith
David Pagel
Charlotte
Jack Draper
Joe Brown
Robert Cormier
Andrew Jensen
Tori and Dalton Abel
Daniel Fidel Perez
Josiah
Shawnee Frerichs

Karen eastwood
Scott and Lori Park
Dylan Harrison
Dan Jindrich
Wendy Huff
Tony Scott
Noah Compton
Timmy Davis
Michael Seeger
Craig Jones
Mike Kettelberger
Todd Krueger
Justin Irani
Keenan Ryan
Nadan Cox
Garrett Billeaudeaux
Ryan Summers
Priscilla Nelson
Will
Roy Tuscany
John Kruper
Jocelyn Williams
Patrick and Cynthia
 Griffin
Karen Nolin
Rotem Shalit
Eli
Scott Peterson
Aaron Dodell

Sinclair
Anderson Guerra
Elijah Garrett
Charles
Octavia Vaughan
Brian J. Cassidy
Julie Higgins
Courtnay Waller
Iliriana Sens
Crystal Miller
Gretchen L. Jameson
Matt McCarthy
Anton Sharapov
Simen Sand
Mark Roberts
Tristen Sharp
Arthur Devaux
Tim Auman
Keaton Noon
Aflatun Asadov
Bobby Stocker
Josh N.
Thomas Murphy
Jocelyn Lykken
Libby Withnall
Colin Richards
Jan Koep
Rax Man
Kris

Lisa Ohrstrom
Torye Cooke
Sukumari Jacobse
Jane Connery
Meagan Evans
Izzy Reep
Wendy L. Welborn
Shara Layton
Ruth Voss
Kristin Mueller
Katty_K
Michael Erkelens
Olivia Jones
Dan Marello
Allison Dunn
Valerie Branham
Angelo Neff

PHOTO CREDITS

Adam Phillips: 104–105
Anton Lilljegre: 54–55, 60–61, 62, 64–65, 68–69
Ashley LaMarre: vi, 82–83, 94–95, 96–97, 126–127, 128–129, 134
Austin Smith: 52–53
Eli Peterson: 43
George Raggets: 94–95
Hannah Haberle: 24–25, 28–29
James Borje-Clark: 12, 15, 40, 50–51
Jo Savage: 124–125
Jon Ross: 80–81
Keri Bascetta: 78–79, 122–123
Liam Pickhardt: Back cover, 92–93, 115, 120, 126–127, 130–131, 132–133
Mark LeBlanc: 70–71, 98–99
Nate Dolin-Aubertin: 104–105, 108–109, 116–117
Phil Parrish: 15
Taylor Maag: viii, 18, 26, 28–29, 54–55, 56, 58–59, 122–123, 124–125,
 126–127
Tom Lebsack: Front cover
Travis Wild: 91, 92–93, 112, 118–119, 130–131
Tyler Genaro: 16